WATERCOLOR: POUR IT ON!

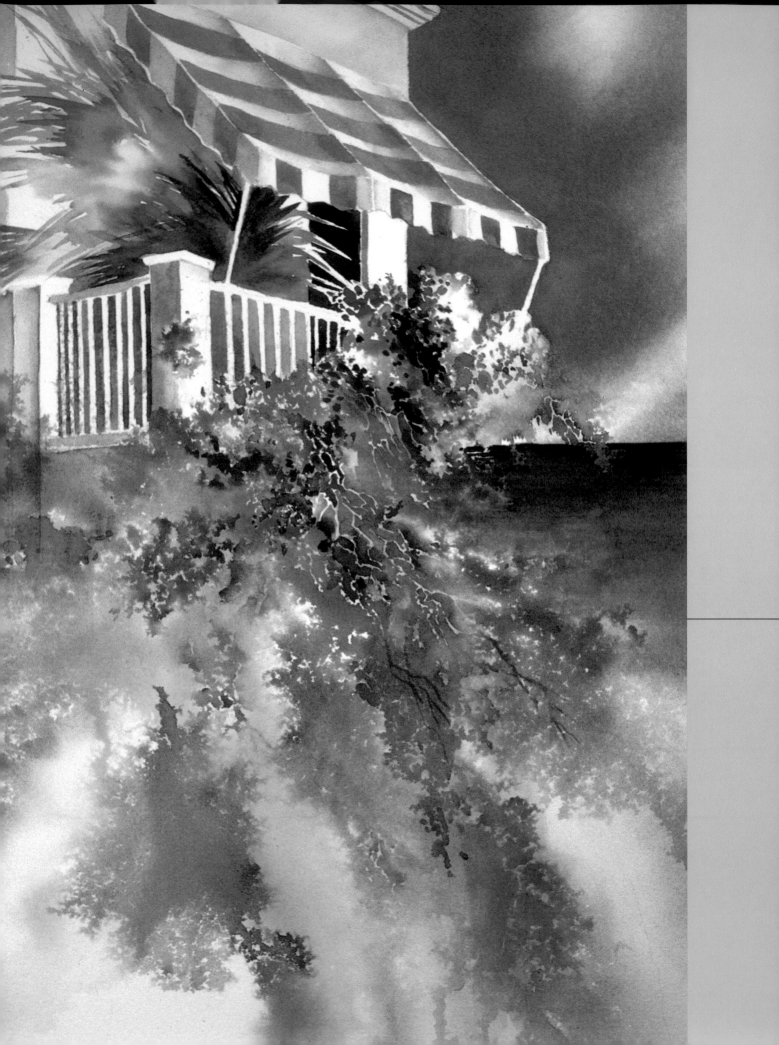

watercolor pour it on!

Jan Fabian Wallake

NORTH LIGHT BOOKS
CINCINNATI, OHIO
www.artistsnetwork.com

about the author

Jan Fabian Wallake is a nationally known professional artist. Her studio is in Stillwater, Minnesota. She has a Bachelor of Fine Arts degree from Bowling Green State University in Ohio. Jan was a graphic designer/art director for many years before becoming a full-time artist. She has taught in the field of design at the college level and now instructs painting workshops all across the U.S. and in foreign locations. Her dramatic painting style of contemporary expressionism is based on geometric shapes balanced with organic forms and the incorporation of glowing color glazes.

Wallake has a six-part TV series on painting. She is listed in *Who's Who in American Art* and has authored several articles for *American Artist* and *The Artist's Magazine*.

Affiliated with several artist organizations, such as Midwest Watercolor Society, Red River Watercolor Society, Northern Plains Watercolor Society and American Watercolor Society, Wallake is a past president of the Minnesota Watercolor Society. Her award-winning paintings are in many corporate and private collections internationally. She is represented by the Pine Cone Gallery, Pine River, Minnesota; MacRostie Gallery, Grand Rapids, Minnesota; Connoisseur of Carmel Gallery, Carmel, California; and the Jan Fabian Wallake Studio/Gallery in Stillwater, Minnesota.

Watercolor: Pour It On! Copyright © 2001 by Jan Fabian Wallake. Manufactured in China. All rights reserved. No part of this book may be reproduced in any form or by any electronic or mechanical means including information storage and retrieval systems without permission in writing from the publisher, except by a reviewer who may quote brief passages in a review. Published by North Light Books, an imprint of F & W Publications, Inc., 4700 East Galbraith Road, Cincinnati, Ohio, 45236. First paperback edition 2003.

07 06 05 04 03 5 4 3 2 1

Library of Congress has catalogued harcover edition as follows:
Wallake, Jan Fabian.
 Watercolor: pour it on! / Jan Fabian Wallake.— 1st ed.
 p. cm
 Includes index.
 ISBN 1-58180-161-0 (hardcover), ISBN 1-58180-487-3 (pbk:alk.paper)
 1. Watercolor painting— Technique I. Title.

ND2420 .W337 2001
751.42'2—dc21 2001030850
 CIP

Editor: Jolie Lamping
Production editor: Stefanie Laufersweiler
Designer: Wendy Dunning
Layout artist: Joni DeLuca
Production coordinator: Emily Gross
Artwork on p. 2-3: **THE BALCONY II;** 21" x 14" (53cm x 36cm);
Collection of the artist

METRIC CONVERSION CHART

to convert	to	multiply by
Inches	Centimeters	2.54
Centimeters	Inches	0.4
Feet	Centimeters	30.5
Centimeters	Feet	0.03
Yards	Meters	0.9
Meters	Yards	1.1
Sq. Inches	Sq. Centimeters	6.45
Sq. Centimeters	Sq. Inches	0.16
Sq. Feet	Sq. Meters	0.09
Sq. Meters	Sq. Feet	10.8
Sq. Yards	Sq. Meters	0.8
Sq. Meters	Sq. Yards	1.2
Pounds	Kilograms	0.45
Kilograms	Pounds	2.2
Ounces	Grams	28.4
Grams	Ounces	0.04

dedication

This book is dedicated to:
Eleanor and Louis J. Fabian

and

Randy F. Wallake
Ragan and Donald MacMillan
Sandra Butalla and Karen Silverwood

in appreciation for their support.

acknowledgments

I would like to express my thanks to Jolie Lamping Roth for her expert editorial talent and to North Light Books for affording me the opportunity to work on this book.

I extend thanks to the following companies for the information they shared: Dick Blick Art Materials, Canson Inc. for Arches paper, Winsor & Newton, Richard Oliver Ltd. and Daniel Smith Artists' Materials. Verra Blough at Wet Paint in St. Paul, Minnesota, generously offered information on products. Richard Jamiolkowski has been a marketing inspiration.

TABLE OF CONTENTS

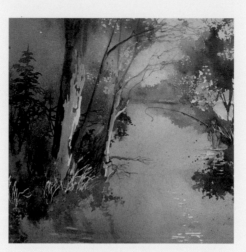

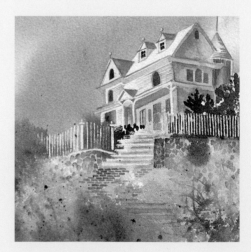

INTRODUCTION

The transparent and fluid qualities of the watercolor medium are so exciting. I remember the first time I saw and admired the flowing colors of a watercolor painting, the freedom of the colors as they merged and swam together on the paper.

Like most artists, I wanted to loosen up with my own art, to experience the free flow of water and pigments and to create pure, glowing colors. As I painted more, I developed the necessary skills and techniques and experimented more with free-flowing pigments. Eventually, I loosened up so much that I did not even use a brush, but rather poured the paints onto my paper and allowed them the freedom to swim around. I now enjoy the painting process most when the paint and water do most of the work. Glazing produces vivid colors that really glow with light. You can create the same glowing colors in your paintings.

This book is divided into six chapters that are organized and formatted for easy learning. You will discover what painting products are best for you and why. You will learn simple guidelines for transforming an ordinary subject into a good composition. You need not fear the watercolor medium if you follow the three-stage building process outlined in chapter four. There is a whole chapter on fun ways to create many different textures within your paintings to add a unique spark of interest. The easy-to-follow step-by-step demonstrations give you an opportunity to follow the painting process beginning at its conception, design and composition, then through initial glazing of color washes, the application of special techniques and the final stages of detail work. Best of all, you will learn how to apply glowing glazes of intense color.

The best art is universal in its language. That is, it has good design, balanced color, direction and movement; and it makes a connection with its viewer. The guidelines in this book are universal in that they apply equally to any subject and to any artistic style, from realism to abstract art. Learn how to use these guidelines to enhance your art. Then loosen up and allow your watercolors the freedom to flow.

MAUI SUNRISE
12" x 20" (30cm x 51cm)
Collection of Nancy Ryan

CARMEL BEACH
15" x 25" (38cm x 64cm)
Collection of the artist

Most artists choose the products they use after a careful
study of quality and performance. But learning the technical
properties of various products
is a challenge for anyone.
I'll tell you what products I
use and why I chose each.
If you understand the
construction, makeup and unique aspects of a product, you
will be able to make informed decisions about which items
are best for you.

MATERIALS

Paintbrushes

How can you determine a good watercolor brush as opposed to a watermedia brush? What qualities should you look for?

When you visit your local art store and find a section for paintbrushes, you may see a sign that reads "watermedia brushes." *Watermedia* refers to any brush that will be OK for any media that is dissolvable in water. That could be watercolors, acrylics, gouache and even water-soluble oil paints. However, an oil or acrylic brush does not need the dispersion qualities that watercolor brushes should have. Likewise, those brushes do not have a sharp point with the spring-back action we watercolorists look for. Check your own brushes. Do the flat brushes have a sharp, natural point (as a good watercolor brush has), or are they chopped off (as an oil brush would be)?

Natural Brushes

The very best watercolor brushes are pure Kolinsky sable brushes. I have tried every brush available and can attest to the fine performance of these beautiful brushes. When you flick the hairs back and forth with your finger, they bounce right back to their natural position. The body of the brush is full, and the tip has a naturally sharp point (not chiseled or cut to shape). The full body of the brush holds a lot of water and pigment. It will afford you a long, continuous painting stroke. The naturally pointed tip will spring back into position after each use and is a good tool for fine lines of detailed work.

The reason that Kolinsky sable (a member of the Asian mink family) hairs make the best watercolor brushes is that the hairs start growing thin, become thick in the middle, and then thin down

again at the base. This natural shaping of each hair occurs only on the tail of the winter coat of the male Kolinsky, a kind of marten that lives in Siberia and Manchuria in Upper China. When many of these tail hairs are gathered together, the resulting brush forms a natural, thin point and a thick, full body. The thick body gives you maximum carrying quality. It will hold a lot of water and pigment and dispense the paint at an even rate all the way across the paper. The point will stay sharp and will spring back naturally.

You will see a variety of other natural hairs used in brushes. Red sable is fine, too, but do not confuse it for Kolinsky. Red sable is of a lesser quality. You may see squirrel hair, ox hair and goat hair. However, camelhair brushes are not made of camel hair. This is a generic name meaning that a variety of hairs were blended into the brush.

Synthetic Brushes

Synthetic brushes drop water quickly at first contact with the paper. Some are very well made, but they simply cannot disperse water as well as a good Kolinsky sable. White sable is a synthetic product and is stronger than natural sable. A white sable brush has a lot of spring in the tip and will push color around well, but it cannot carry a wash of color across the paper like a Kolinsky sable.

Caring for Your Brushes

Once you have made your choice of brushes, take special care in using, washing and storing them. New round brushes often come packaged with a clear plastic sleeve over the hairs to protect the tip during shipping. Remove the sleeve, and do not attempt to resleeve the brush. You might catch a few hairs and bend them back, causing permanent damage to your new brush.

The best way to wash your brush is to tap it against the inside of your water container, but *not* the bottom. Then, holding the brush with the handle up, pinch the tip of the hairs and move the brush in small circles. This will create an osmosis, drawing water up into the ferrule. Tap the brush against the inside of your water container again and then squeeze the hairs dry. Repeat this process until the water running out of the brush is clear. Your brush will be free of all pigment right up to the ferrule. If you follow this procedure, you will never need a brush soap or cleaner, both of which can damage natural hairs.

✳

THE BIRTH OF A BRUSH

I visited the factory in Ireland that makes my signature brushes. I met Delia, who, for thirty years, has expertly gathered and positioned the sable hairs into various-sized nickel ferrules. When Delia offered to let me try my hand at this task, I gained a whole new appreciation for her skill. She separates the precise amount of hairs for a given-size brush, taps them into a small metal tube that aligns the hairs, then she twists the hairs into a rustproof, seamless, cupronickel ferrule. The hardwood handle is glued into the other end of the ferrule with a strong cement compound, and the brush is ready for use.

Storing Your Brushes

The best way to store a brush is to hang it with the hairs pointing downward. This will allow gravity to pull the moisture away from the ferrule. If this isn't possible, lay it flat to dry. If you store your brushes upside down (hairs pointing up) in a container, the water and any residual pigment will collect near the ferrule and eventually ruin your brush.

Buying the Best Brushes

Brush hair quality and construction will affect the performance of your painting strokes. Buy the best brush you can. Look for a sharp, springy point; a natural, full body; and a seamless nickel ferrule. Avoid purchasing any brush with a seamed ferrule. Water will seep into the seam and stay trapped inside the ferrule, loosening the adhesive that holds the hairs in place. The end of the wood handle that enters the ferrule will expand and eventually break down the brush. Proper care in washing and storing your brushes will give you a lifetime of use.

✻
KEEP A VARIETY OF BRUSHES ON HAND

My paint box holds an array of Kolinsky sable brushes, from a 1-inch (25mm) flat to a no. 3 round, but I also have a few synthetic brushes for mixing colors and even some old oil brushes for lifting paint or adding texture.

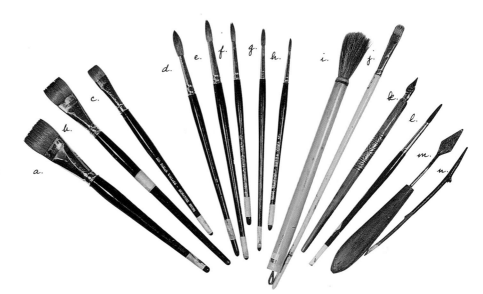

I have a lot of brushes, but these are my favorites: pure Kolinsky sable 1-inch (25mm) bright **(a)**, ¾-inch (19mm) bright **(b)**, ½-inch (13mm) bright **(c)**, no. 9 round **(d)**, no. 8 round **(e)**, no. 6 round **(f)**, no. 5 round **(g)**, no. 3 round **(h)**. I use additional tools for specific purposes. Floppy Oriental brushes **(i)** are good for spattering or throwing paint onto the paper (Winsor & Newton brushes shown). An old oil painting brush **(j)** can lift paint once it has dried on the paper. I use a dip pen **(k)** to draw fine lines with watercolor paint. A no. 12 Grumbacher round synthetic brush **(l)** is useful for mixing paint in my paint cups. A palette knife **(m)** is excellent for pulling fine lines of paint or masking fluid; I like to indicate twigs or branches with it. One day, when I was painting on location, I found myself without a palette knife. I sharpened a twig **(n)** and used it to draw a line of water and paint down the paper. I have been using this homemade tool ever since.

Paper

Watercolor papers come in a wide variety of finishes, surface textures and qualities. Each offers unique opportunities to enhance your artwork. Here are twelve guidelines to help take the mystery out of purchasing the right watercolor paper for your artwork.

Surface Finish

There are three main surface finishes for watercolor papers: hot-press, cold-press and rough. A standard-sized sheet is 22" × 30" (56cm × 76cm).

Hot-Press

A smooth finish is called hot-press. The newly made sheets are pressed between calender rollers to smooth the surface. Hot-press paper has a glossy, hard, even finish that's ideal for detail work. It gives a characteristically mottled look to watercolors.

Cold-Press

Cold-press paper (also called "not" or "not hot") has a moderate texture on the surface. The cold-press surface texture is made when cotton pulp passes through the cylinders of a papermaking mould next to a sheet of felt. The impression left by the felt creates the surface texture of that sheet. This texture is referred to as "tooth." Cold-press papers have a visible yet unobtrusive finish that is good for broad, even washes as well as detail work.

Rough

The dramatic "pebble" appearance of rough-surfaced paper makes a loud statement. As you brush a wash across this surface, the pigment will drain off the hills and settle into the valleys of this finish, creating a slightly impressionistic effect. Use this paper when you want a dramatic surface pattern to make an impression in your painting.

Texture

There are many surface textures among the various brands of watercolor paper. A cold-press from one manufacturer, for example, can be quite different from that of other papermakers. This surface landscape of pattern and texture gives each brand its unique characteristics. Try painting on several sheets from various manufacturers. You will find that the personality of each sheet flavors your work in distinctive ways and may even offer you the initiative to paint differently than you have before.

Weight

Paper thickness is important to watercolor painters. Like any paper, watercolor paper will buckle and curl when wet.

* WORKING ON SMOOTH PAPER

When I started painting on a smooth-textured paper, I was energized by the unpredictable slipping and sliding of the paints on this smooth surface. I made adjustments in my painting techniques and loosened my control so that the paper could perform. For example, I use more water when I apply a wash on hot-press (smooth) paper than I do with cold-press. Water evaporates unevenly on a smooth surface, so using more water and more intense pigments allows a little more time to work before hard edges begin to dry around puddles of paint. These edges form interesting designs that do not occur on a more textured paper. Do not try to control the puddling. Choose smooth-textured paper when it will enhance the image you want.

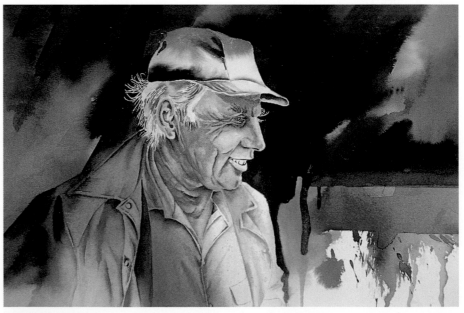

FARMER FRANK
9½" x 13" (24cm x 33cm)
Collection of the artist

Thicker paper will have less buckling than thinner sheets.

When you buy 140-lb. (300gsm) paper, that weight indicates what five hundred sheets (a ream) of that specific paper weigh. So, five hundred sheets of 140-lb. (300gsm) paper weigh 140 pounds. Five hundred sheets of 300-lb. (640gsm) paper weigh 300 pounds.

You can buy watercolor paper by the single full sheet (22" × 30" [56cm × 76cm]) and in packs of five, ten or twenty-five sheets or more. You can buy rolls of paper and cut off whatever you like. You can get a 40" × 60" (102cm × 152cm) sheet for large-scale work. These sheets are called "double elephant."

Watercolor paper is also sold in a block. This is a tablet of paper that has been bound on all four sides with a rubberized seal. Although manufacturers claim that these sheets are stretched, the sheets are not really stretched but merely bound together. They will buckle when wet, they will stay damp longer than a single sheet because the underlying sheets retain moisture, and they are expensive. However, smaller blocks can be useful for on-location painting. When your painting is completed, simply insert a palette knife under the top sheet (there is a break in the seal at the top center of the block) and run it around the edge to release your work.

Deckle Edge

A deckle edge is a slightly ruffled edge resulting from the actual papermaking process. When paper is made by hand, a frame, called a deckle, is placed over a screen to prevent pulp from going back into the vat. As the paper is formed, the edges become uneven. Some paper mills mechanically produce this edge on their machine-made or mouldmade sheets. It is a beautiful characteristic of fine papers.

I like to retain the deckle-edged quality, so I always tear my watercolor papers instead of cutting them. To do this, I carefully fold the sheet where I want it to separate, first folding it in, then out. I repeat the folding several times, then I dip my fingers into clear water and run them along the seam on both sides. This softens the crease, so I can easily pull the two sections apart. The tear has a pseudo–deckle edge and is in keeping with the original edges.

The Right Side

Quality papers often have a watermark. Paper mills use a screen surface to transform the paper pulp into the finished sheets. At the same time, they impress their company logo onto one or more corners of the newly formed paper. You know you are using the right side (the side the manufacturers intend for you to use) if you can read the watermark correctly.

I put a small x on each corner of a sheet when I intend to tear it into smaller sheets. This way, I can easily tell which side is the right side even on the pieces that have no watermark.

Papermaking Types

There are three basic types of papermaking processes: handmade, machine made and mouldmade.

Handmade

This is a slow process of forming one sheet at a time. It allows for great subtlety and character.

Machine made

The Fourdrinier papermaking machine was invented at the turn of the nineteenth century. It allowed paper to be produced in large quantities. The paper surface is very even, and the integrity of the paper is dependable.

Mouldmade

In this process, a vacuum is created in a large cylinder that rotates in a vat of pulp or rag. The vacuum pulls the material onto a screen, and this forms the paper sheets. Most of today's watercolor papers are made with this process.

Toughness

Some watercolor papers are capable of taking a lot of abuse, such as scrubbing, sponging, etc., and the surface remains viable. Other softer papers cannot withstand overuse.

I found out the hard way just which papers to avoid. I was well into the third part of a five-part series on water lilies. Because I was glazing large expanses of pond water, I used masking fluid to preserve the already painted lilies. Then, I poured on beautiful glazes and was very excited about the results—until I tried to remove the masking fluid. The soft-surfaced paper I had chosen for its whiteness was not able to hold up. The top layer of paper pulled up when I removed the masking fluid. Now, when I know I will be masking, I choose a hard-surfaced paper like Arches, Saunders Waterford or Fabriano Uno. (See page 17 for more information on choosing the right paper for your work.)

Absorbency

This factor is important to watercolorists. Fine watercolor paper will absorb just enough water to allow the pigment to sit on the surface without feathering out.

Sizing

The amount and application of sizing determine the absorbency of a sheet of paper. Sizing is an organic gelatin, a glue-like substance that helps the paper hold paint in place and keeps paint from running. Sizing is applied to paper fibers during the papermaking process.

Paper can be either hard sized (a lot of sizing applied) or light sized (less sizing applied). The more sizing that is on the paper, the more strength and durability it has. Whether a paper is hard sized or light sized also determines how the paint will settle on the paper. For example, on hard-sized paper the paint will not settle into the paper fibers as much as it will with light- or soft-sized paper. Without sizing, watercolor paper would be like a blotter.

There are three main types of sizing applications: internal, surface and tub.

Internal

Internal sizing means that the gelatin has been added to the vat during the paper-making process, when the pulp is mixed. That means that all of the fibers are equally sized. This is best for watercolors because if paint is lifted off the surface fibers, the internal fibers will react in exactly the same way as the surface fibers.

Surface

Surface sizing refers to the process of adding sizing only onto the surface of an already formed sheet. These sheets of paper are generally used for printing and are not recommended for fine art.

Tub

Basically, this is a variation of internal sizing—the surface and internal fibers of the sheets are equally sized. In tub sizing, however, the organic gelatin is added in a separate stage. The newly formed paper is put back through a sizing bath.

Tub sizing yields a deeper-sized paper. This reduces the overall absorbency of the paper and makes a very resilient sheet. The best fine art papers are tub sized.

Whiteness

You will notice a wide range of white tones when you compare various manufacturers' watercolor paper. Lanaquarelle and Winsor & Newton, for example, each produce nice white papers that are especially good for brilliant colors and luminosity. Arches, which I use often, has a slightly less white coloration, but it has other superior qualities I like: good surface texture and a stretchable, harder, more durable surface that resists tearing.

Acidity

Acidity yellows paper over time. It can cause paper to crumble and disintegrate. Choose a paper that is acid free, and be sure to store it flat and in a dark place, away from the harmful effects of ultraviolet rays.

Surface Fibers

An important characteristic of fine watercolor paper is the formation of the fibers that lie on the surface. Avoid laying anything down on your watercolor paper. Anything that touches the surface will depress the fibers and compromise the reflective quality of the paper. Light bouncing off the even surface texture gives the transparent glow we all love about watercolors.

Remember, every job is unique, and a paper that suits one use may not suit another. It is a good idea to sample papers before committing yourself.

Look for paper qualities that best suit your painting style and objectives. Today, papers are made to last a long time. Good watercolor paper has a three hundred-year life. Even museums, formerly fearful of collecting watercolors on paper due to their questionable longevity, are now becoming secure in the permanence of paper fibers.

The paper chart on the opposite page shows some of the papers I use.

Paper Chart

	Typical Characteristics	Best Suited For	Not Well Suited For
Arches 140-lb. (300gsm) cold-press	Versatile Nice even surface texture Durable	Pouring glazes Scrubbing and lifting paint Most watercolor techniques	
Arches 140-lb. (300gsm) hot-press	Smooth surface texture Absorbent	Detail work Watery drips and puddles	Reworking and lifting paint Soft edges
Arches 140-lb. (300gsm) rough	Nubby texture	Impressionistic textures Drybrush	Detail work
Arches 300-lb. (640gsm) cold-press	Heavy, uneven texture Highly durable Leaves speckled highlights when swept with pigment Stretching not required Takes a long time to dry	Direct painting Plein air painting	Poured glazes
Fabriano Artistico 140-lb. (300gsm) cold-press	Light sized Absorbent Off-white Needs stretching Only two deckle edges	Painting that needs a lot of pigment without losing luster and translucency Colors that will remain dark when dry	Reworking paint
Fabriano Uno 140-lb. (300gsm) soft-press	Even surface Bright white Hard sized Velvety texture (between hot- and cold-press)	Reworking and lifting paint Glazing	
Lanaquarelle 140-lb. (300gsm) cold-press	Bright white Soft texture Hard sized Odor free Less buckling when wet Easy to use and control	Glazing Washes of paint that will glide easily over surface	Reworking paint
Saunders Waterford 140-lb. (300gsm) cold-press	High quality Hard sized White Good surface strength and texture No odor when wet	Reworking and lifting paint Glazing Detail work Achieving translucent colors	Achieving deep values
Strathmore Imperial 500 140-lb. (300gsm) cold-press	Light sized Absorbent	Glazing over opaques Drybrush	Reworking paint Soft edges Smooth transitions
Strathmore 140-lb. (300gsm) hot-press	Even, smooth surface White	Detail work Achieving translucent colors	Reworking paint
Whatman 140-lb. (300gsm) cold-press	Bright white Light sized Absorbent: colors even out and soften Colors tend to bleed	Drybrush	Reworking and scrubbing paint Hard edges

Paper Supports

A paper support is a surface on which to lay your watercolor paper. The board you choose will depend on what type of painting you intend to do, such as wet-in-wet, plein air, glazing, etc.

Basswood Board

The best paper support is a basswood board. Be sure to get a good-quality basswood, not a thin basswood laminate over another board. Art stores will carry the best boards. These boards are of a medium weight, are best for stretching paper and will last for many years.

Gator Board

Gator board (not to be confused with foamcore board, which is a paper-covered foam sheet) is a good lightweight support board. It is approximately ½"-thick (1cm) foam with a waterproof plastic surface. For stretching paper, this board accepts staples easily, and they remain firmly anchored. However, after many uses the foam-based board will break down and stretching will become harder to maintain.

Homasote

I have used a product called Homasote for quick paintings in my workshop classes. This is a building product that can be purchased at builder supply stores or lumberyards. It is inexpensive and can be cut to any size. I do not use it for anything larger than 15" × 22" (38cm × 56cm), half of a standard 22" × 30" (56cm × 76cm) sheet, because it tends to warp when it gets very wet. It does take staples effortlessly and is reusable. I would not recommend leaving your paper attached to this board for very long, as it is not acid free.

Plexiglas

When I am painting outside, I often use 11" × 15" (28cm × 38cm) sheets of paper placed on a 12" × 16" (30cm × 41cm) piece of Plexiglas. Of course, I cannot stretch paper on this surface, but quarter sheets do not always need to be stretched. If I give the back side of my paper a quick spray with water and clip the paper to the Plexiglas with large metal paper clips, it will stay flat while I paint.

Avoid using Masonite as a paper support. It is heavy, and you cannot staple down your paper. Plywood is also heavy and does not accept the ordinary desk-type staples needed to stretch paper.

Choose a paper support that you will be able to carry easily. Look for basswood, Gator board or Homasote for a reusable board on which you can staple down watercolor paper. For travel and plein air painting, try a piece of Plexiglas with some metal clips.

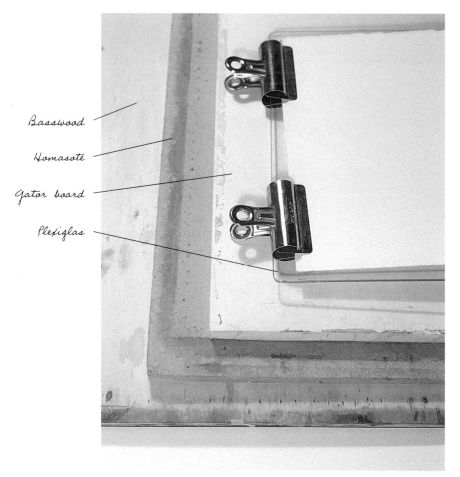

Basswood
Homasote
Gator board
Plexiglas

TYPICAL PAPER
SUPPORTS

Stretching Watercolor Paper

There are many good reasons to stretch your paper. For glazing, especially, it is important to avoid the rippling that occurs when the paper gets wet. Glazing should produce a fine, even wash that is not mottled or streaked. When paper ripples, the pigments in a wash (or even in a single brushstroke across the paper) slide down off the hill and settle in the valley formed by the buckling of the paper. The result is a dark streak. By stretching the paper before you begin painting, you can easily eliminate this problem. (Flattening the paper after the painting is completed will not solve the dilemma.)

Some people pay the higher price for 300-lb. (640gsm) paper because it does not need to be stretched. It is heavy enough to withstand buckling when wet. I think that 140-lb. (300gsm) paper is expensive enough. Stretching takes only a few minutes.

✳
TEN EASY STEPS FOR
STRETCHING PAPER

[STEP 1] Run several inches of room-temperature water into a tub, large sink or tray. Gently slide the paper into the water. You may see tiny bubbles appear on the surface of the paper. This is the sizing bubbling out. Slide the paper back and forth, turn it over, and again slide it back and forth. This will break the bubbles and assure that every part of the sheet is wet. Allow the paper to soak for fifteen to twenty minutes.

[STEP 2] Remove the sheet from the water. Allow as much water to drain off as possible. Be careful not to touch the paper except on the edges. (See "Surface Fibers" on page 16.)

[STEP 3] Lay the sheet on your paper support with the right side up. Can you read the watermark? Be sure to use a support that will accept ordinary desk-type staples easily.

The soaked paper is softened and can be stretched. Pull the edge until a good ripple appears down the center. The final stretched piece will actually be approximately ½" (1cm) larger than it was before stretching.

[STEP 4] With a stapler, put four staples close together in the middle of one edge. When working on a full sheet, start the stapling on one of the short sides. Place these staples about ½" (1cm) inside the edge of the sheet. Always work from the outside in so that your stapler does not rest on the paper.

[STEP 5] Turn the board around to the opposite side. Pull the paper toward you. If you pull hard enough, a ripple will form down the center of the sheet. Hold the edge down with one hand and staple four staples close together in the center of this edge with the other hand.

[STEP 6] Repeat steps 4 and 5 on each of the other two sides. Pull the paper at one corner and secure it with two staples.

[STEP 7] Turn the board to the opposite corner (diagonally), stretch hard, hold and staple.

Turn the board diagonally to the opposite corner. Stretch hard, hold and staple.

[STEP 8] Now stretch and staple the remaining two corners.

[STEP 9] Finish by stapling around the paper's edge every two inches (5cm). Allow the paper to dry. Your sheet will be approximately ½" (1cm) larger due to this stretching and will stay taut like the head of a drum.

[STEP 10] After the paper dries completely, apply a 1½" (4cm) strip of masking tape over the staples and onto the support. The tape keeps the poured glazes on the paper, offers a place to write notes, and prevents a wash from draining off the sheet and seeping under the stapled edge, resulting in the edge staying damp and perhaps forming a bloom.

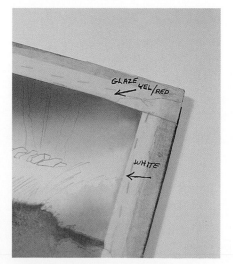

Taping the edges protects the staples from loosening and prevents water from seeping under the paper. The tape also provides a place to write notes on color or the direction of a glaze, or a reminder to save whites.

Paints

A few tubes of pure, brilliant, professional-quality paints will produce the best results. Most manufacturers also offer a less expensive line, but these are student-grade paints. There are three basic differences between high-quality paints and the student lines.

1. **Cost.** Paint prices are based on how finely the pigment is ground, how rare the raw material is and, finally, the ease of manufacturing. Student-grade paints are the least expensive because they contain less pigment, the pigment is coarser ground and these paints contain a clay filler.

2. **Transparency.** Pure, finely ground pigment is actually transparent. That is, light will go through the tiny specks of pigment and bounce off the paper below. You may hear of opaque transparent pigments. This means that the specks of pigment are not transparent but are ground so finely that they can be applied transparently. In this case, light will simply bounce off the paper around the specks of pigment. They can also be applied opaquely so that no light reaches the paper. The clay filler used in student-grade paints automatically diminishes transparency.

3. **Permanence.** Professional-quality paints are labeled with a permanence code. Permanence is the rated durability of paint on paper when displayed under glass in a dry place, freely exposed to ordinary daylight and atmosphere. A lightfast rating of A or AA will assure you of a permanent pigment. Look for it on the tube or pan color packaging.

Mediums

Mediums can aid watercolor paints in several ways. For example, gum arabic is a commonly used medium. It increases brilliance, gloss and transparency. It produces more granulation of pigments and reduces bleeding effects. Oxgall improves wetting and flow on hard-sized paper. I often add a few drops to my water container.

Granulating Colors

Some colors are granulating. These pigments separate or mottle when washed onto the paper. This is a natural, inherent quality and should be used to its advantage. In general, these traditional pigments granulate: cobalts, earths, ultramarines. Sometimes distilled water will reduce granulation.

Staining Colors

Staining colors are those which cannot be lifted off the paper once they are put down. Modern, organic colors, like Hooker's Green, Indigo, Aureolin and most of the cadmium colors, for example, are made of very finely ground particles that cause them to stain. The intensity of the stain can be reduced somewhat by adding gum arabic to the paint. Look on the tube for a staining classification. You can also check a color chart at your art store for this information.

Nonstaining Colors

Nonstaining pigments do not bite into the paper and dye it. These pigments can be lifted from the paper and are best for glazing because they do not compromise the underlayers of glaze. Nonstaining colors will not destroy the translucent quality of multiple layers of glazing. If I must use a staining pigment for a glaze, I generously dilute it with water.

I use Winsor & Newton Artists' Water Colours and Daniel Smith Extra Fine Watercolors. These paints are of unusually fine quality. I choose only A- or AA-rated pigments. Purchase pigments that have a high permanence rating and brilliance—defined as intensity and depth of color, purity and transparency.

Palette

When I first began painting with watercolors, I was very concerned by the cost of quality paints. I chose a number of Winsor & Newton colors, filled my John Pike palette and trotted off to my first workshop. Worried about wasting my paints, I made tiny dime-sized puddles of the colors I needed for the day's painting. The instructor noticed my frugal ways and awarded me the "skimpy palette" award.

I knew I had to change my outlook on mixing large pools of paint, yet I was still worried about waste. That is when I discovered the butcher tray. It is an 11" × 15" × 1" (28cm × 38cm × 3cm) enamel tray. The bottom is slightly convex. I squeeze out approximately ten colors onto preplanned locations on the palette floor (some colors, like Winsor Red, I

place up onto the inside wall of the palette because they are so strong they would contaminate the other colors on the palette floor). I allow these globs of colors to dry out completely. When I am ready to paint, I activate the palette with a spray of clean water.

I mix large pools of paint by simply dragging my brush over various colors until I get the desired color and amount and the right consistency of paint. The paint sits on the palette floor for a while, eventually running off to the sides and down to the bottom edge. (I place a thin sponge under the top edge of the palette to elevate it and encourage the paints to run downward.) As these paints run to the bottom edge, they mix with any other colors I use in that particular painting. I cleverly call this my "dark" color. It is

different with every painting. It is a unique, dark pigment that is color harmonized with each painting.

Often I dip my brush into this dark color instead of my water pail. Remember, every time you rinse your brush in the water pail you lose paint. By wetting my palette with a spray bottle and utilizing my dark color, I conserve almost all of my paint. The only time I rinse my brush in clean water is when I need a clean, pure color. This palette forces me to mix colors and blend large pools of paint, and as a bonus, it creates color harmony.

Do not cover your watercolor palette. This will cause the pigments to mildew. When you finish painting, allow the pigments to dry out, then re-wet them when you are ready to reuse them.

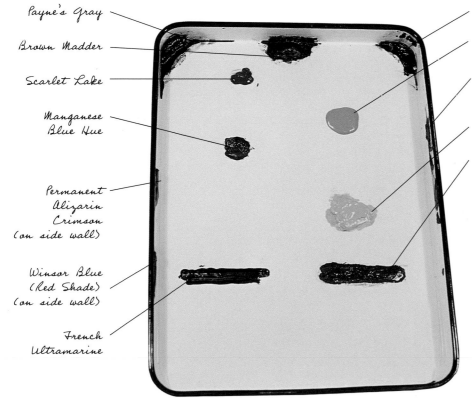

Payne's Gray
Brown Madder
Scarlet Lake
Manganese Blue Hue
Permanent Alizarin Crimson (on side wall)
Winsor Blue (Red Shade) (on side wall)
French Ultramarine

Antwerp Blue
Aureolin
Winsor Red (on side wall)
Winsor Yellow
Cobalt Blue

MY PALETTE

I have several butcher tray palettes, each with a different combination of Winsor & Newton colors. This is the one I use most often. I have arranged the colors in specific areas. The earth colors, Brown Madder, Scarlet Lake, Aureolin and Antwerp Blue, are grouped at the top. Winsor Red, Cobalt Blue and Winsor Yellow are my purest primary colors. I use them for atmospheric colors. They are grouped on the lower right side. The reds are placed up on the sides of the tray because they are strong reds and will contaminate the other color pools. I simply brush over the red and pull the color down when I need it.

Pouring Cups

For glazing, I use individual containers (the plastic measuring scoops that come in some laundry detergent boxes are perfect) to mix larger pools of color. I want the purest, most transparent colors for these glazing pigments. I have a variety of each of the three primary colors, but I also mix colors in some of the cups. The best policy is to use repeated pourings of pure colors to achieve the desired glazed color. For example, to get a glowing green, I pour on Aureolin, let it dry, pour on Antwerp Blue, let it dry, and repeat with the Aureolin for a warmer green. By this overlapping of glazes, I can control the color and the intensity of the glaze.

I have quite a stack of color cups. When I finish with a color, I allow the water to evaporate from the cup. The pigment is still there and can be activated with water when I am ready to use that color again. I can control the consistency (I prefer the consistency of milk) by mixing in just the right amount of water.

GLAZING COLOR CUPS
My pouring or glazing colors are separated into individual cups. I let them dry out when I am not using them. It is easy to add water and mix to a milky consistency when I am ready to use the colors again.

Your Studio

If you can, locate a space that can become your own painting area—a space where you can work and leave your equipment; an area with good, natural light. When I first started to paint with regularity, the only place I could find was a window area in a guest bedroom. I set up two small cabinets in which to keep my supplies and laid a Formica-covered board over the top of them to paint on. That was my first studio.

Today, I am lucky to have a beautiful studio, which I was able to design myself. There are big windows to take advantage of natural light, daylight-balanced halogen lamps, both vertical and horizontal shelving for storage, a large shallow sink for soaking papers, an office/computer area, library space and lots of gallery space. My photography setup is in a windowless room adjacent to the studio.

STUDIO WORK AREA
My worktable is in a bright bay window area. The table is large, and there is a long table next to it on which I keep all of my painting equipment.

*

CHOOSING YOUR STUDIO SPACE

When you choose your studio space, whether it is simply a corner or a full room, look for these qualities and equipment:

- Privacy
- Good, natural light
- Water source
- Daylight-balanced lamps
- Cabinet or taboret (to hold and organize your equipment)
- Work surface (large enough to accommodate your painting, palette, brushes, water container, etc.)
- Large mirror (Viewing your painting in a mirror often reveals trouble spots you may not otherwise see, such as weak value patterns.)

STUDIO OFFICE
This office space is essential for me. My computer, fax, phone, library and files are all conveniently located here.

[2]

PLAN A ROUTE

In the process of developing the eye of an artist, you will learn to create more exciting pictures. An artist's eye looks for patterns and satisfying arrangements of colors, lines, values, spaces or shapes, and textures. These are the basic elements of design. The organization of these elements is called *composition*. An understanding of how to use the elements will help you plan a route to a successful design for your painting.

Design exists in everything around us, from a simple pebble to a massive mountain. You can find color, line, value changes, shapes and textures in all of nature, in the human form and in man-made objects. The arrangement that the various elements take on is what describes a particular scene. For example, it is the color, shape, texture and line of a pebble that reveal its existence.

An artist has the unique ability to convey an image by arranging the elements of design into a pattern that not only reveals a scene but also sends a message. The best art is not about simply painting a picture, it is about offering a personal insight within that picture. Personal imagery begins with a good understanding of the simplest, most basic units of design. Learning how to use them gives an artist infinite ways to see the world and share a unique statement.

Let's take a look at each of the elements of design. Since they are basic to all of existence, it is important to begin to see them in your subject matter. Later, we will learn how to compose a painting by combining, exaggerating, manipulating, repeating or eliminating various elements in order to emphasize a point of view. The inspiration may be as simple as a lone pebble, but individual handling of design elements can turn it into a dramatic work of art.

Also, at the end of this chapter are five fun exercises to help let loose your creative spirit.

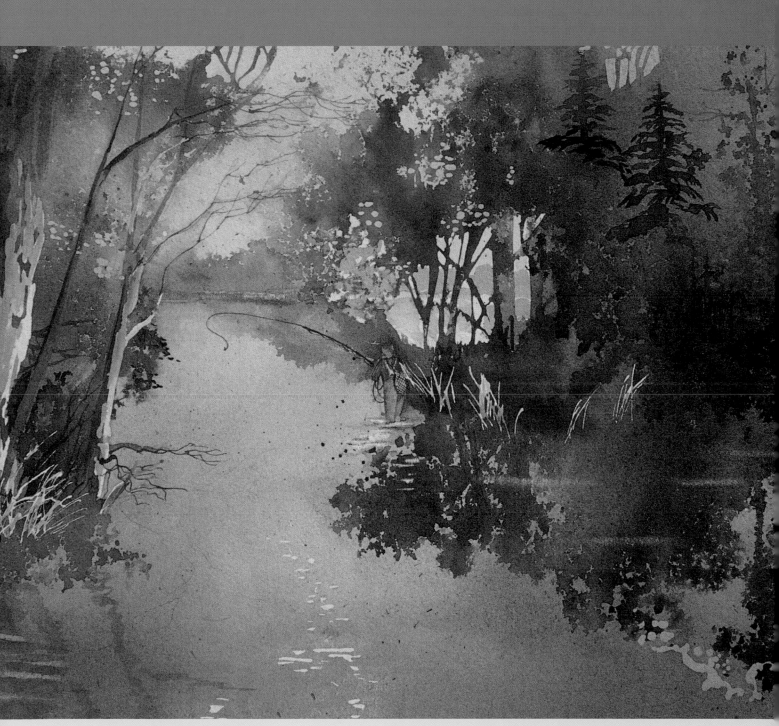

CASTING THE FLY
14" x 21" (36cm x 53cm)
Private collection

Color

Hue is the name given to colors. White, gray and black are called neutrals. Color is a visible fact of nature; it depends on light to distinguish it from gray. The amount of light determines the brilliance of the hue. Too much light creates a whiteout effect; too little light diffuses all pigment into deep, subdued tones.

There are three *primary* colors: red, yellow and blue. They are located equidistantly on the color wheel. Knowing how to use the color wheel is key to the success of your painting.

Mixing any two primary colors produces a *secondary* color. For example, if you mix red and yellow, you will get orange. A secondary color is located between its two primaries on the color wheel. Likewise, yellow and blue produce green, and blue and red make violet. If you mix a primary and its adjacent secondary color, you will have a *tertiary* color. To illustrate, red mixed with orange yields red-orange. There are six tertiary colors on the wheel.

The color wheel is divided into a warm side and a cool side. Red, orange and yellow are warm colors, while green, blue and violet are cool colors. (This is a generalized statement since color temperature depends on surrounding hues. See chapter five for more information on color.) The temperature of a color offers a sense of feeling or mood. Red, for example, incites fire, rage, passion. Blue is calming. Cool colors recede, while warm colors advance. This is one way artists create an impression of depth on a two-dimensional surface.

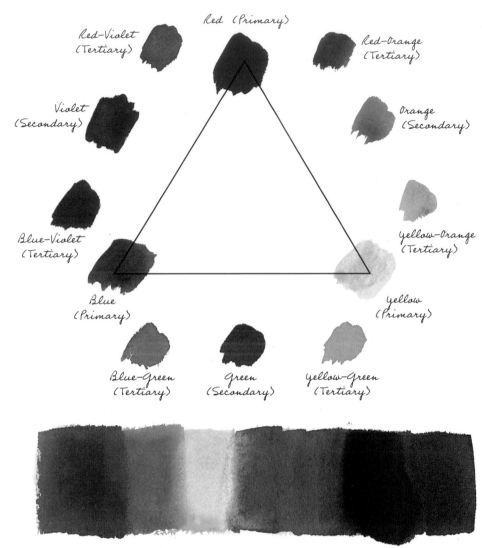

Analogous colors blend naturally

THE COLOR WHEEL
By mixing two primary colors, you will produce a secondary color. By mixing a secondary with its adjacent primary, you will get a tertiary color. With as little as three pure primary pigments, you can mix twelve or more colors. Analogous colors (side by side on the color wheel) blend naturally into each other. This is important to know when glazing, so your colors do not become muddied.

Side-by-side colors on the color wheel are called *analogous* colors. These colors blend naturally one into another. Therefore, the flow from one hue to the next is an easy progression that does not hinder the properties of each individual color. They are harmonious colors. This is important when glazing, since pigments swim together.

Complementary colors are those directly across from each other on the color wheel. Complementary colors actually vibrate off each other, enhancing the chroma, or brilliance, of each color. A red rose will appear to be a much brighter red if it is surrounded by green leaves. A yellow lemon will appear more intensely yellow if surrounded by a strong violet color. This is one way of utilizing the element of color to attract attention in your painting.

Picasso used color for mood extensively in his Blue Period. Your challenge as an artist is to exploit the qualities of color, to use them in natural or unnatural mixtures to produce mood. Judge the color palette you use by the mood you want to convey. Choose color carefully, and remember that sometimes fewer colors or even various tones of one color have more influence than incorporating many colors.

COMPLEMENTARY COLORS
Notice how the red is much more brilliant surrounded by the green. When used next to each other, complementary colors cause a vibration in the cone cells in our eyes. The result is that each color appears more intense than it would if used alone or with an analogous color.

A LIMITED PALETTE
This painting began with a glaze of only three colors: Brown Madder, Yellow Ochre and French Ultramarine. I chose blue and its complement, orange (mixing Brown Madder with Yellow Ochre), for the conflict they imply, but I subdued the orange tones with white spaces to keep a more somber mood. The white spaces as well as the soft edges are a good relief to the subject's intense expression. To finish the piece, I painted with a darker value of each of those colors to pull the figure out of the background, and I added Burnt Umber for a stronger value contrast near the face. By using a limited palette, I was able to integrate the background with the subject.

THE DOUBTING OF MR. DePAUL
7" x 10½" (18cm x 27cm)
Collection of the artist

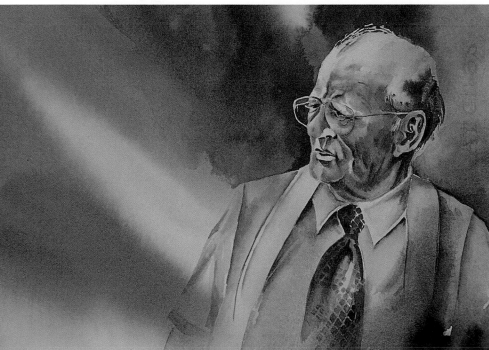

Line

Each single line has two dimensions: length and width. It also has the ability to express emotion. It can dance. It can be limp, rigid, nervous, angry. Lines can be either straight or curvilinear, continuous or intermittent. Use line to separate shapes or areas. Use them to join areas and to direct visual movement in your painting.

The character of a line is as varied as your imagination. Artists can take advantage of the fact that every line has two sides. One side might be hard-edged, while the other side is soft-edged. I often use this varied-edge application when painting. The hard-edged side will describe a shape. The soft edge eases out to a vignette.

Line divides space. It describes an image and tells us how it relates to its surroundings.

Two lines that become closer in the distance tell us that there is depth in the painting. A soft line conveys an easy peacefulness, restfulness. My favorite way to use line in a design is to create movement. Dramatic linear markings that swirl, skip or glide across a painting take a viewer on a visual rhythmic trip. Sometimes, I use a combination of marks to activate an emotional response and to direct an eye path at the same time. Line does not have to do all the work, however. Combine it with shape for an effective attention-grabbing design.

Implied line is also effective. Rather than describing an entire shape with line, rely on the viewer's imagination to carry a line. Offer just enough information to get your point across.

No. 9 round brush

Push down for a heavy line; pull up for a thin line.

½" (13mm) flat brush; broad side stroke

Vertical tip stroke

A line with two hard edges

A line with two soft edges

A line with one hard edge and one soft edge

LINE VARIATIONS

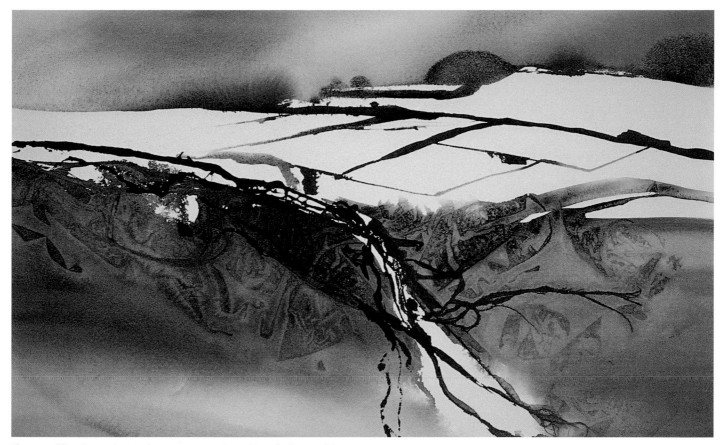

The use of line in an almost abstract pattern gives this painting a cold, wintery feel. That is the mood I was after. A limited palette of colors and the tangle of lines in the foreground add to the impression of the winter landscape. Line is descriptive, but it can also be compelling as a design tool. The stark, hard-edged lines that divide fields in the snow draw immediate attention to this cold landscape. I used line as well as white spaces to open up the composition on the bottom edge (see "Butterfly Theory" on page 43). Other lines are muted and add interest in the foreground. An active zigzag of diagonal lines keeps the eye moving, but a soft wash in the sky and immediate foreground counter its effect.

PRAIRIE LANDSCAPE—WINTER
17" x 28" (43cm x 71cm)
Collection of the artist

Value

The eye sees light and dark before it recognizes color. Value is the relative lightness or darkness of a color. Objects that are relatively close in value tend to merge together, like distant mountains. Values that have a great contrast are glaring and attract attention. An interesting pattern of values can help lead a viewer through a painting and direct attention toward the focal area, also referred to as the center of interest or focus. A value pattern can also create movement in a painting.

I like to use a strong value contrast at the center of interest. If I choose this design element to attract attention, I am careful to use middle to light values as I move away from the main area of interest, because they will support, but not distract from, the strong contrast at the focal point.

Using too many value shifts or placing them sporadically about the painting can be confusing to a viewer. Also beware of isolating spots of strong value contrast,

each of which will grab for attention. A viewer will not know where to focus. Instead, connect value patterns with movement toward the focal area.

Organize and plan the midvalue pattern just as you plan the dark value pattern. The dark to middle tones and/or the mid to light tones will not compete for attention, but they do support the stronger value contrast at the center of interest and, therefore, are very important to your overall design.

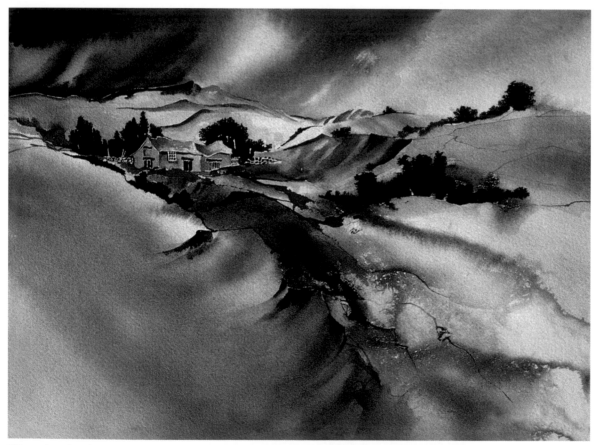

This on-location demonstration painting was a lesson on developing a dark value pattern that will lead the eye toward the center of interest, which in this painting is the hillside farmhouse. The lights or whites should form an interesting pattern that complement the dark pattern. Notice how the light pattern allows the eye to rest, and yet each white or light space is interesting in its shape and contour. The darker values move toward the center of interest in an active pattern, while the light shapes move toward it in passive or subtle patterns.

BEYOND CRESTOW
10" x 14" (25cm x 36cm)
Collection of Janet Montgomerie Taylor

Shape

Form or *shape* refers to an area. Shape can be geometric or organic. Some geometric forms are triangles, cones, rectangles and squares. They can be open or closed, active or static. For example, architectural shapes are rigid and hard-edged. Organic shapes are less defined than geometric ones. These include natural forms and human, animal and other living forms that can flow and move.

In addition to the positive shapes of actual objects, there is shape to the spaces around those objects. Develop an eye for the negative shapes; they have form too. Usually, the positive shapes of objects stand out, but negative shapes can dominate over positive shapes to create unique visual impressions.

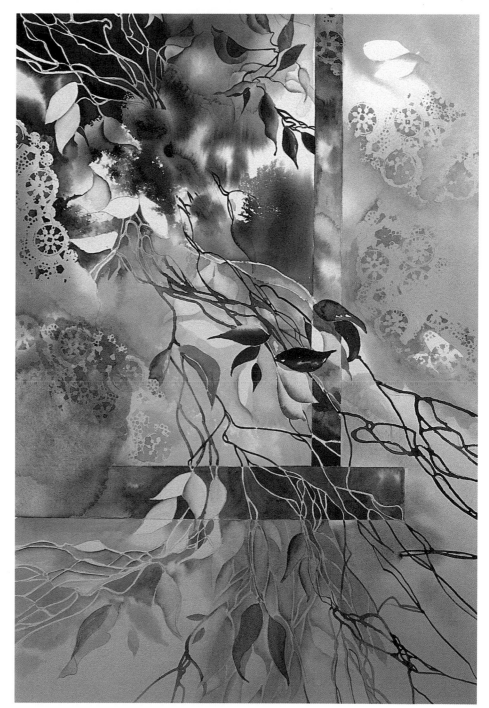

I worked on a series of plant-in-the-window paintings. This one is expressionistic in style but still has a recognizable theme. Organic objects are more pronounced if combined with geometric shapes. Positive shapes are more interesting if countered with negative ones. I exaggerated the element of line by painting lots of vines. In this case, the overall design was more important than rendering a realistic subject.

WINDOW VISIONS
27½" x 17" (70cm x 43cm)
Collection of the artist

Discover Shapes in Your Paintings

To understand how solid shapes are affected by the negative space around them, cut geometric shapes of various sizes out of black paper. Move the shapes around the design area and overlap some shapes. By moving part of one or more shapes off the edge of the design, you can give the impression that your subject lives beyond the frame, and that adds intrigue. Remember to use a variety of sizes with your shapes. For example, a basket of roses is much more interesting if some are in full bloom and some are just buds. Likewise, it is more interesting if some shapes overlap others. The basket of roses will have depth and look more natural if some flowers are tucked behind others.

Avoid bringing any shape just to the edge of the painting area. For example, it would be better to carry the top of a tree right off the edge of the painting than to have it just touch the edge. This creates an undesirable nervous tension. The tip or point of any shape that just barely touches one of the four edges of your paper is visually irritating because it psychologically evokes a poking sensation. Also avoid aiming any shape toward a corner; it leads the eye quickly out of the picture.

Now look at the arrangement of shapes you have planned out. Do the solid shapes connect into a pleasing pattern? Are the negative shapes interesting? Do both positive and negative shapes work together to enhance the overall design? Is there a focal area, an area of the design toward which all shapes lead the eye?

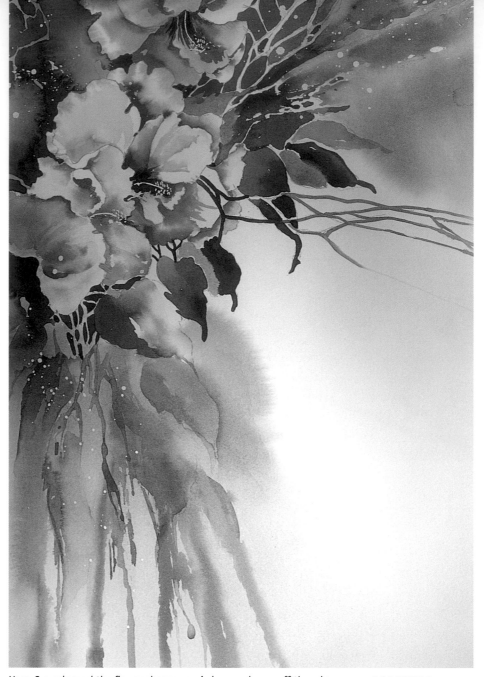

Here, I overlapped the flower shapes, carried some shapes off the edges, varied sizes and used both positive and negative shapes. A large part of the painting has been left unpainted. This area creates a shape just as important as the floral shapes. The lower right portion of the painting is quiet and restful. It counterbalances the active shapes at the top. All of these shapes lead to and support the flowers as the center of interest.

HIBISCUS
21" x 14" (53cm x 36cm)
Collection of Kitty Chandler

✳
ARRANGING SHAPES IS KEY TO GOOD DESIGN

French Postimpressionist Paul Cézanne altered the direction of art when he questioned traditional realism and looked at the arrangement of shape as the basis for design. His interest was not to paint realistic pictures; his focus was on a balanced design. He was prepared to sacrifice conventional correctness for a more interesting composition. Cézanne showed us a new way to look at the world. Shape and how it relates to the other elements of design is more important than subject.

Compositions get confusing when so many shapes stand alone.

There is nothing leading the eye to the focal point (large circle).

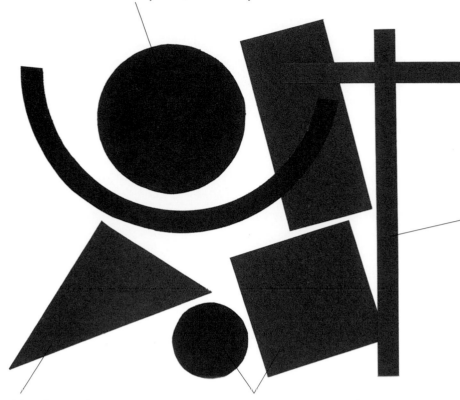

UNBALANCED COMPOSITION

If we reduce all objects in a scene to their most basic form, we can arrange the geometric shapes into a good composition. This example highlights several errors. There is no recognizable center of interest. No directional pull leads the eye on a path toward a specific area. Some shapes are just touching the picture's edge, which causes a visually irritating "poke." Other shapes aim toward a corner and lead the eye out of the composition. This arrangement is chaotic.

Placing the vertical or horizontal line parallel to the paper's edge creates dead space in the area between the line and the edge of the paper.

These shapes are fighting for attention. Without a directional pull, the eye wanders from form to form.

This shape points at a corner, directing the eye off the paper.

These shapes are placed right on the edge of the visual area, creating a nervous tension.

There is a directional pull toward the focal point (large circle). All other shapes support this thrust.

Negative spaces are interesting shapes.

The horizontal line is slanted and creates a better negative space, adding interest.

A BETTER ARRANGEMENT

Here are the same geometric shapes arranged in a strong composition. Notice the directional pull of dark shapes toward the focal area. All shapes lead the eye to that part of the composition. Both dark and light (or white) shapes are interesting in their form. Some shapes travel right off the perimeter, indicating that the composition continues beyond our visual scope. This arrangement of shapes offers intrigue.

Carrying shapes right off the edge indicates that there is more to the composition.

Overlapping shapes add strength and create a dark value pattern that works to support the center of interest.

Texture

Our sense of touch is stimulated by the element of texture, which is used when an artist wants to create an illusion such as a crumbled wall or a velvety soft fabric. Sensory responses attract attention. They beckon us to come closer, to feel and become part of the painting. This is a distinctive visual technique for an artist, one that requires discriminating treatment because too much texture can override the message.

The placement of textural areas should support the overall focus, not dominate it. You will find an abundance of texture and pattern right at your doorstep. Nature provides textural designs on every surface. Focus on close-up details, cross sections or surface qualities. These alone can become the inspiration for a painting. Regardless of whether textures are used as abstract images or to enhance a realistic concept, they will surely add interest and intrigue to your work.

You can achieve a sense of texture in many ways. For example, hold a flat or round brush parallel to the paper surface and drag it sideways to create a dry-brush texture that is great for old wood images or weeds and grasses. A razor blade will scratch fine lines for interesting textures. Your choice of paper and its surface quality is another way to introduce texture. Rough-surfaced paper offers a nubby texture, while smooth surfaces promote drippy puddles. If you use granulating pigments, you will get a mottled texture; as the paint dries, it naturally separates on the paper.

I like to use a variety of applicators to achieve specific textures. Sometimes I use a straw to blow tree branches or dip a piece of lace in paint then press it on the paper to suggest a doily. A spattered texture is great for trees. These no-brush applications often add the sparkle that enlivens the painting. Chapter three shows many of the techniques I use.

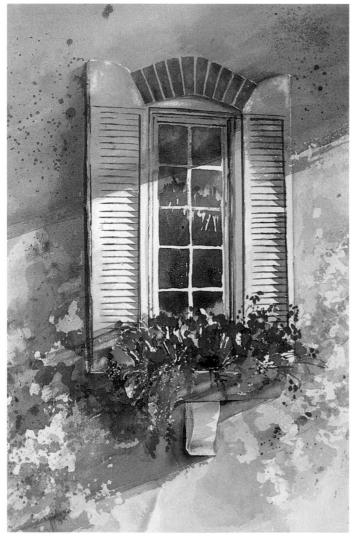

I soaped up my dampened natural sponge, dipped it in masking fluid and then patted it onto the watercolor paper to create a look of stucco for this wall. Then I rinsed the sponge clean of soap and masking fluid so that it would not dry and harden. Next, I dipped the clean sponge into Winsor & Newton Yellow Ochre and patted it onto the paper. This gives a positive texture of pitted stucco, while the masked pattern will bring out a negative texture. Last, I glazed over some of the patterned areas with the same Yellow Ochre and added a glaze of Payne's Gray in other parts. When it was dry, I removed the mask. Patterns of texture are ideal if they support the theme and are used with discretion.

WINDOW BOX
13" x 9" (33cm x 23cm)
Collection of Mr. and Mrs. Jack Butalla

Take a Tour

Without movement, a painting is simply a picture. It is wallpaper. There are lots of ways to direct the viewer's attention, to lead the eye into and around a painting. Like a good novelist, an artist starts with an intriguing plot, develops supporting characters, creates conflict and ultimately leads to the main focus of the story. Principles of art such as elimination, exaggeration, repetition, emphasis, movement and contrast will help you lead your viewers on an exciting journey through your painting.

Elimination

The first step in planning a painting is to ask yourself, "What do I want to say? What is the focus?" A good center of interest is the starting point. After you have considered each of the elements of design, look at your sketch. Make certain that you have not included more than what is needed to get your idea across. There is always the danger of saying too much; the result is confusion, and that causes a viewer to lose interest.

Decide on one thing you will convey in your painting. It may be an object, a mood, maybe the joy of an early sunrise. Then, evaluate all of the other parts of the scene. Do you really need those daisies in the foreground? Are there too many lemons in your still life? So what if there was a telephone pole in the scene on location. Does it contribute to the unique message of your design? If it does not, eliminate it.

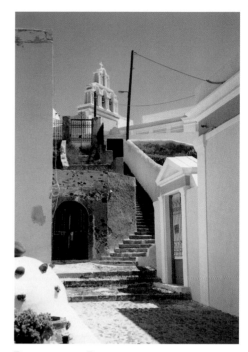

REFERENCE PHOTO

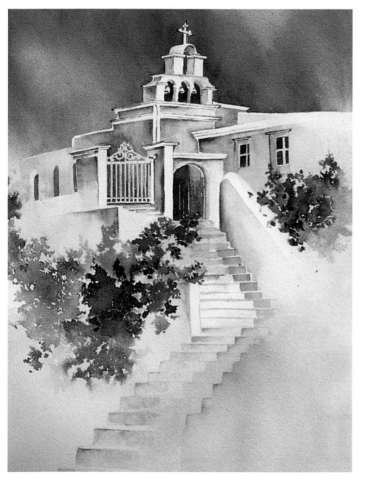

On-location painting at my workshop in Santorini, Greece, offered a real challenge. Everywhere I looked, there were spectacular sights. As I looked at the scene shown in the reference photo above, what most impressed me were the chapel bell structure and the long staircase, so I concentrated my design on those two things. I have photos to remember the actual scene; the finished painting captures its essence.

SANTORINI BELL TOWER
15" x 11" (38cm x 28cm)
Collection of Barbara Diasparra

Exaggeration

One way to make a bold statement in your art is to exaggerate. The deviation from what is real will attract attention. Overstatement might be accomplished with size difference, color embellishment, value contrast, dramatic sweeps or even outrageous distortion—in short, anything that magnifies or stretches reality. The important thing is that you are in control. You can manipulate your subject so that viewers know exactly what you want to say.

Repetition

Any time an artist uses a recurring pattern or line, it draws attention. Repetition may be used to direct an eye path toward a specific area or to attract focus to the duplicated item itself. A recurring line or pattern is a powerful attention grabber, so use it wisely. Too much will cause a nervous tension in a painting. Beware of using it in fragmented areas. Because of its obvious attracting qualities, it can easily take the focus away from the center of interest. I sometimes glaze over the areas of repetition to tone down the effect while keeping its distinct design benefit.

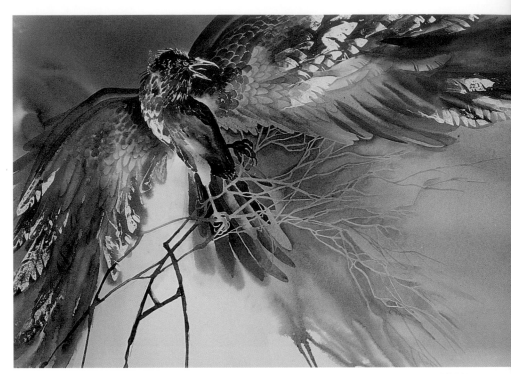

To accentuate this bird's rage, I magnified the outspread wings to an enormous proportion. I chose to exaggerate the wings because of their dramatic sweep and because the feathers held an intriguing opportunity to create a violent pattern of shapes and values. *Raging Raven* is more about the mood than it is about a raven.

RAGING RAVEN
20" x 27" (51cm x 69cm)
Collection of the artist

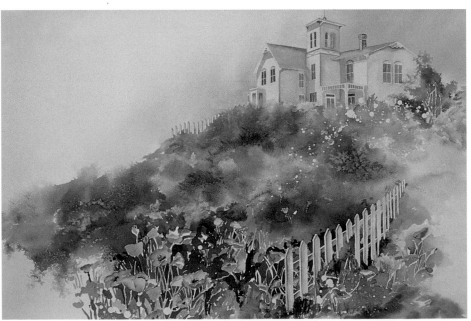

I tucked a picket fence into the foreground poppy field to attract and lead the eye toward the focal point. Notice an echo of that same fence type in the far distance. Repetition adds interest and directs attention.

VICTORIAN POPPY FIELDS
20" x 28" (51cm x 71cm)
Collection of Armand Laurent

Emphasis

In design, emphasis, sometimes called dominance, refers to an area or object of focus. It is what demands viewer involvement because it is predominant. It has the strongest impact, and all other areas and objects flow toward it and support it. Emphasis, or center of interest, rivets the eye and leaves an impression. You might achieve emphasis simply by size. One large flower, as Georgia O'Keeffe painted, will draw attention. You might use a strong color for emphasis, or you can use any form of intense contrast, like value change, hard edges in a field of soft edges, detail amid illusion, line that directs attention, or positive shapes next to negative ones.

Movement

Movement is the flow pattern in a painting. Movement is necessary to enliven the scene, to give it a sense of progression from one area to another. This means that the scene is not stagnant, rather that it has a life, and we are encouraged to explore where the movement leads us.

By jockeying the basic elements—color, line, value, shape and texture—and manipulating the principles of art—elimination, exaggeration, repetition, emphasis, movement and contrast—an artist can create a fascinating visual journey through a painting.

Movement in art can, but does not necessarily, mean motion. Sometimes movement is implied with a rhythmic pattern that carries the eye from one place in your painting to another. Sometimes movement is suggested with a sweeping brushstroke that offers an illusion of activity. I often use the element of line to incite movement around my

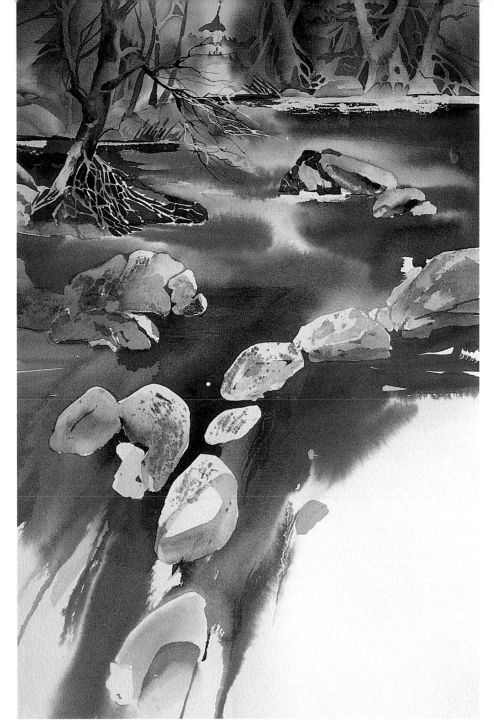

The movement in this painting was developed in the initial glaze of the first wash. I wet the top half of the paper and then splashed clear water down and off the bottom. When I poured on the pigments, they ran and flowed in a natural movement. The vertical trees, horizontal shoreline and dramatic diagonal of flowing water accentuate the principle of movement.

RIVER WILD I
23" x 12½" (58cm x 32cm)
Collection of the artist

painting. Even color transition or color temperature change can create movement. I consider the possibilities of how to use movement in my initial planning of a painting.

There are three directional design techniques I use to create a sense of dramatic action and move the eye around a painting. These are horizontals, verticals and diagonals.

Horizontals

Tranquility and restfulness are emphasized by the use of a horizontal design. Think of all the horizontals in life and nature: a reclining figure, a calm sea, the prairie, a distant line where sky meets earth. The landscape is full of peaceful, level lines. They are a stabilizing force in a composition. If you emphasize the horizontal in a painting, it will give an overall sense of calm. Be sure that is the effect you want.

As an artist, you have the option of suggesting a horizontal line without actually drawing it. An implied line is often more powerful than a literal one. Maybe a wet wash of color glazed in a horizontal direction will lead to a provocative movement in your painting.

You might try a "lost and found" line. This is a line that is hard edged, becomes soft edged and perhaps disappears at one point then reappears. This offers the illusion of a horizontal line and adds interest. Be mindful of the danger of dividing your paper in half with too strong a horizontal line. Your composition will suffer from the symmetrical division, and it will cause unpleasant conflict with your center of interest. Remember, something in your painting should dominate, and all other parts of the design should support that focal area.

Verticals

You might decide to counter the calming effects of horizontals by contrasting them with verticals. These up-and-down forces rebel against earth's gravity. They imply energy, growth, strength. Verticals offer a regal quality, an implied pride in height. The spirit of the vertical force will add energy to a painting.

Vertical designs do not have to run exactly perpendicular on your paper. In fact, they are more interesting if they are tilted slightly. For example, a tree that runs straight up the side of a painting creates a dead space between that tree and the paper's edge. If you slant the tree into the image area it will not only offer a directional force but will be more interesting to the composition.

Use a vertical direction in your composition to empower the design. If your aim is to paint a bold attention grabber, exaggerate a soaring vertical.

Diagonals

There you are, sitting in front of your painting. You have managed to incorporate all of the elements of design in useful ways. Those fancy techniques you learned in your last workshop make a good impression. The horizon line is nicely countered by a few towering trees slightly slanted into the picture. There is a strong focal area. It is a good painting.

Now, step away from your work. Are patterns of motion directing your eye? You have horizontals and verticals, but if you add a diagonal sweep, the painting takes on a whole new power. Diagonal thrust has an extraordinary inherent drama. It shoots across the composition, sweeping your attention along on a lively ride.

Imagine a vertical wall with a flat roof that is supported by a diagonal strut. It is that diagonal beam that supports one element, restrains the other and connects the two securely together. Diagonal designs in art perform the same functions.

Control the use of this powerful tool. If you decide to include a dominant diagonal sweep in your composition, make it a logical part of the overall design. For instance, a prairie landscape might have a stormy sky that blows downward with majestic sweeps of the brush. That picture would be all about the dramatic pull of diagonal strokes in the sky. If, however, you are using a diagonal for the directional movement your composition requires, then control the force by slowing its power. You can do this by zigzagging. Instead of one strong stroke, create a series of counter diagonals. Move the pattern first one way, then the other. Of course, one direction must be dominant, but the effect of the path will be less conspicuous.

Contrast

Contrast, or conflict, is the give and take, the push and pull, the good and evil of a situation. How can you express this in your art? It might be the subject of your work, or it might be less obvious, such as the colors you choose. Perhaps the friction between complementary colors attracts just the right amount of attention in a specific part of your painting. Maybe the contrast of white paper next to deep values of color suggests a struggle of will, or the discord of soft vs. hard edges might create friction. Using the element of line against quiet areas of a pure, even wash is one of my favorite ways to use contrast. We will explore more ways to use contrast in chapter five.

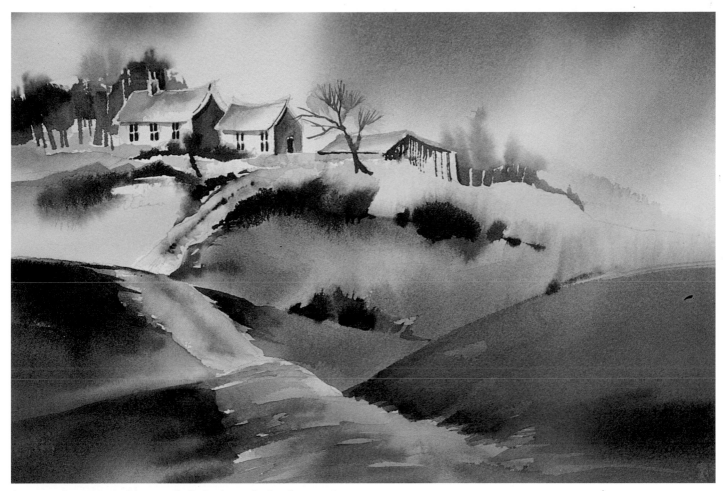

A strong value contrast with a very limited palette of colors focuses attention on the overall design of this composition. Here I used a zigzag pattern for the path that opens up at the foreground and moves toward the center of interest, which is the house. For this composition, it is more interesting to alter the path, angling it in different directions instead of making a direct diagonal path, and it carries the same dramatic benefits. Play with your composition until you have an exciting design.

NEAR NOTTINGHAM
10" x 14" (25cm x 36cm)
Private collection

Begin the Journey

When I go on a trip, I like to have a fair idea of where I am going, how I will get there, what I want to see along the way and what the ultimate destination will be. Of course, I like to leave room for a little adventure, some unplanned surprises. It is fun to veer off the planned route for a while and explore, but I do not want to lose sight of my final goal.

I approach a new painting with these same thoughts. Watercolor lends itself naturally to unplanned surprises. Like a good trip, these can be some of the best parts. By using the basic elements of design and principles of art, we can take a viewer on an exciting journey through our art.

Sketch

On a piece of sketch paper cut to the exact size of my intended watercolor, I begin to develop my composition. I want to sketch full size so that I will not have to guess at proportions when it is time to transfer the drawing to the watercolor paper. Using sketch paper frees me to mark, erase, move objects and make notations.

The first question I must ask is, "What is the focus of this piece?" The center of interest will be the final destination, but I want to make the trip to it interesting. I will think about how I want to attract attention to the focal area. Then, I will use any or all of the elements and principles of art to create an intriguing movement through the painting.

It is great to be able to draw with proficiency, but I believe that an impression is more engaging than photo-realist depiction. Illusion is more captivating than realism. One way I like to begin a new design is to do a contour drawing where my pencil never leaves the paper. Holding my soft-lead pencil perpendicular to the paper, I relinquish some control. Now I can be intuitive. I am looking at the object or scene, but I am quickly marking in shapes with an eye for both the positive and the negative spaces. Detail and exactness are not my goal. I want to capture a loose, free image of what I see. My pencil dances around the paper with an expression of what I see and feel. The resulting sketch may need some refining. I might eliminate some lines or add others to better describe my subject. I will need to adjust some shapes, develop a value pattern and emphasize and create movement toward the center of interest, but the overall design will be a unique rendition of the subject.

I often carry this kind of presketch a step further. A blind contour uses the same technique with the added challenge of not looking at the paper while you sketch. I cast my full attention on the subject to be sketched. With my pencil held loosely in a vertical position, I draw the subject, never lifting my pencil, mindful of positive shapes and negative spaces. I am free to move about the subject without being bogged down by the detail. This is the ultimate in free design for me. Sure, there is an initial shock when I look at the mangle of lines I blindly sketched. Sometimes it is downright humorous. After I have a good laugh, I get down to business and find a design. I eliminate, add, exaggerate, repeat or do whatever I feel will get me closer to the design. Many of my most successful paintings have been conceived with a blind contour sketch.

PREPARING A SKETCH

I begin a sketch for a new painting with the best intentions, but sometimes objects need to be reduced, enlarged, eliminated or perhaps moved. For *Red Babushka*, I decided to reposition the old lady and add other figures in the background. Instead of erasing and redrawing, I cut and paste. All of this preplanning on sketch paper helps me arrive at a good design, and I do not have to draw and erase on my watercolor paper. Once the design is satisfactory, I transfer it to the watercolor paper using graphite paper.

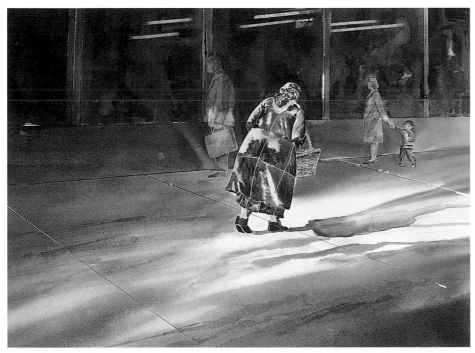

An old beggar lady was walking along the platform of a train terminal in Budapest, Hungary. I saw her from our passenger window. It was late afternoon, and long shadows slid across the pavement. This painting exaggerates the lonely feeling I got from that scene. I eliminated almost everyone from the bustling railroad platform. Two figures appear in muted tones in the background. A small boy is looking directly at the old lady in her babushka. Low light, deep colors and medium to dark values carry the somber mood. The only strong value contrast is at the center of interest. In this painting, I eliminated unnecessary people and background shapes, exaggerated the mood with subdued tones, emphasized the lone figure with the strongest value contrast at the focal area and used the lines of long cast shadows to direct movement. I overstated the diagonal design by casting deep shadows. In this piece, I used the elements and principles of art to re-create a mood and tell a story.

RED BABUSHKA
20" x 28" (51cm x 71cm)
Collection of the artist

BLIND CONTOUR FOR *PLUM LINES*

REFINING THE DESIGN

This painting is a study in contrast and design, complementary colors (red and green), hard and soft edges, illusion vs. detail, positive and negative shapes, as well as line and mass areas. I also added the geometric, man-made shape of the window to contrast the natural, organic subject.

PLUM LINES
27" x 16" (69cm x 41cm)
Collection of the artist

When you feel secure with your design, transfer the primary parts of the drawing to your watercolor paper using a sheet of drafting graphite paper. The sketch is the same dimension as the watercolor paper, but you can still shift it a bit if needed before transferring.

[STEP 1] Place the graphite paper dark side down on your watercolor paper. Place the pencil sketch on top of it. Tape it down so that nothing shifts.

[STEP 2] Trace over the sketch with medium pressure on your pencil. Too hard a line will gouge the watercolor paper; too soft pressure will not allow the transfer to show up. A very pale line will dissipate into your first washes of color, and you will be forced to retransfer the sketch.

[STEP 3] Make a few practice lines before you start. You do not need to trace every tiny sketch mark. Trace only the most important shapes. This will allow you some freedom as you paint.

Trace your sketch onto watercolor paper.

A Memorable Trip

Subject matter is made up of the design elements—color, line, value, shape and texture. After choosing the dominant theme (center of interest) for a painting, you must next decide on the best way to go about telling your story. The critical work of developing a painting involves decisions on design. What composition best dramatizes the center of interest or focus of the painting? What direction and movement will lead viewers on the most exciting journey? What can be exaggerated? What can be eliminated? What is the most effective design to promote the desired impact? When you begin to relate to potential subject matter with these questions in mind, you emerge from painter to artist. Being an artist is not about replicating nature; it is about communicating a personal vision. Don't worry about whether your art is pretty; worry about whether it is effective.

THE BAR THEORY

If you divide your composition into three equal horizontal parts, a top (background), middle and bottom (foreground), it will be boring. If you alter the proportions of those bars, they become a design tool you can use for dramatic effect. This painting has a small background, a medium-sized middle ground and a large foreground. I often use the exaggerated foreground for its dramatic quality.

ROUTE ONE FARM
20" x 28" (51cm x 71cm)
Collection of the artist

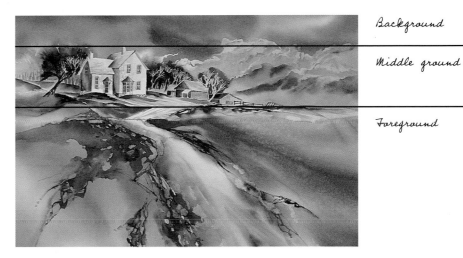

Background

Middle ground

Foreground

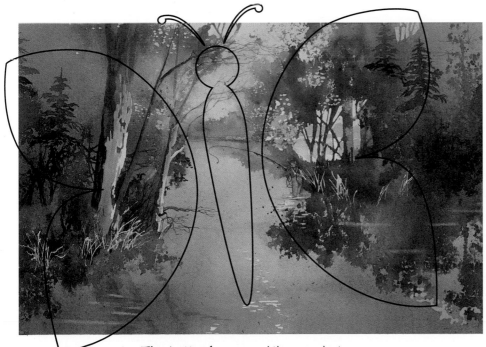

The butterfly composition reminds us to open up the bottom of the painting to allow a visual path into the image.

BUTTERFLY THEORY

Imagine a butterfly with outstretched wings. That pattern makes a good guide for remembering to open up your composition. Viewers enter a painting from the bottom. Opening a path from the bottom invites the eye to enter and explore your composition.

CASTING THE FLY
14" x 21" (36cm x 53cm)
Private collection

In *Freedom Glider*, soft diagonal sweeps of color in the sky converge with an opposing diagonal line formed by the wave. The soft glazes in the sky contrast with the active movement of the linear patterns in the water. The gull is the focus of this piece, so I exaggerated the wings and dramatized the value contrast.

FREEDOM GLIDER
15" x 11" (38cm x 28cm)
Collection of the artist

Creativity Exercises

Draw a Blind Contour

If you want to loosen up the control of your art, try this liberating approach. Choose a simple subject, and draw it without looking at the paper you are drawing on. With the subject in front of you, place the point of a pencil on the paper. I usually start at the top of the paper. Now, begin to draw the shapes in your subject as you follow the outlines with your eye.

This exercise is called blind contour because you must not look at the drawing paper as you draw the subject. Look at the subject only, and reproduce the outline of the forms by moving your pencil around as your eye explores the shapes. Blind contour drawing will free you from the constraints of realistic reproduction and guide you toward self-expression in your art. Create an expressionistic image with this drawing technique, and then use it to paint very unique impressions.

SUBJECT BLIND CONTOUR

Discover Shape

Shape is one of the most important aspects of good composition. Learn how to see shapes instead of actual objects. This lesson exaggerates shape over every other element of design. Set up a simple arrangement of objects. Your objective is to draw only the negative spaces in the arrangement. You will not draw the objects themselves, only the shapes of the spaces between and around them. Look at the design of the negative shapes. This can be the start of an intriguing painting.

If you want to develop your skill at combining shapes into an interesting composition, try breaking each form down into its geometric base. For example, an apple would become a circle; a banana would become a long rectangle. You can cut these shapes out of black paper so that they can be moved about, or you can try sketching them on drawing paper. Consider a variety of sizes, adding or eliminating shapes and perhaps overlapping some shapes. Is there direction and movement in the arrangement? Is there a focus toward which the composition flows? Arrange the shapes until you are pleased with the design, then set in order the actual objects of your still-life arrangement. With this groundwork on the design of shapes, you can be assured that your painting of the still-life arrangement will be off to a good start.

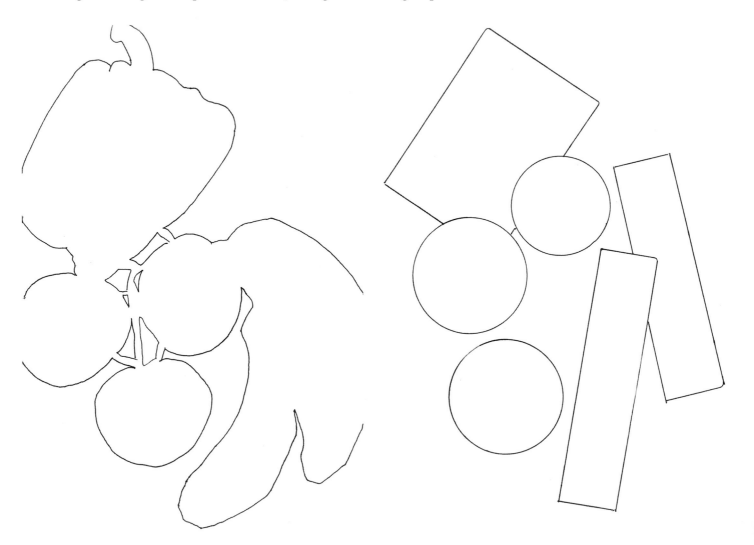

Look at the design of the negative shapes.

Break down each shape to its geometric base.

Toss a Mat

Push your creativity with this "accidental subject" exercise. You will need a mat; one with an 8" × 10" (20cm × 25cm) opening works well. Go outside and throw the mat up into the air. No second chances here; whatever is showing in the mat opening when it lands is what you will develop into a painting. If the mat lands on a gravel road, develop that image into a painting. Find a place for a focus (center of interest), and choose a means of attracting attention to it. Maybe you will use brighter color in that area; maybe you can describe the focal area in greater detail than the rest of the painting. You have many choices. This is an excellent test of your skills at using the elements of design and the principles of art.

ACCIDENTAL SUBJECTS
After tossing the mat, develop the image within the mat window into a painting. Define shapes, enhance value, add color or exaggerate textures.

Use the elements of design and principles of art discussed in this chapter to develop your accidental subject into a work of art.

Explore a Subject

To really know a subject, we must analyze it, scrutinize it and probe the traits that make it unique. This exercise helps an artist learn to observe rather than simply see a subject.

An apple is a good object to use for this exercise. You already know what an apple looks like and could paint a pretty good likeness of it without even having one in front of you. However, you may be surprised at the unique traits and markings on an apple if you examine it with an artist's eye.

Place an apple in front of you. Mix each color you see on the apple in a separate pool on your palette. You can sketch the apple or paint it freely. Paint the apple in each of the following four lessons.

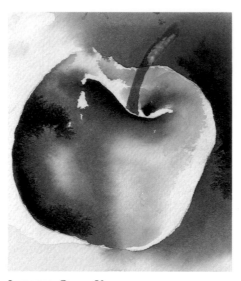

LESSON ONE: VALUE

Paint the apple with a light source on one side. Use only one color for this part of the exercise. Consider the roundness of the shape. Concentrate on using the white of the paper for the lightest value. Integrate a medium value and a very deep, dark value.

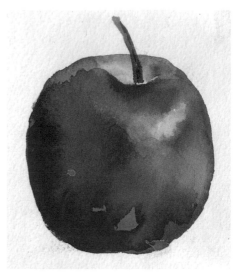

LESSON TWO: CONTOUR

Using the lesson learned by painting the apple in one color, paint another apple with values of several analogous colors. In this lesson, try to use as few brushstrokes as possible. Allow unblended areas of paint to settle as they will.

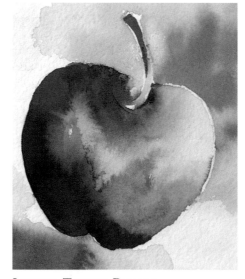

LESSON THREE: DRAMA

This lesson incorporates value and contour along with a dramatic flair. Choose a series of analogous colors. Develop a background and continue painting into the apple area. Remember to leave some white areas within the apple. Release a drop of clean water into the still-damp paint on the apple. It will cause the paint to crawl back, creating a bloom. These natural markings can infuse fascinating patterns into your painting, but beware of overdoing any special technique.

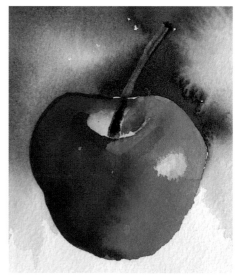

LESSON FOUR: INTEGRATION

This lesson bridges the background to the subject. Paint the apple with value, contour and drama. When it is dry, develop a background that will enhance yet not distract from the apple. Try the water drop technique in the background. Use colors that are in the apple or compatible with those.

Paint Clean Color

You will become confident in your approach to watercolors as you become more experienced. The more you paint, the better you will be at it. Whenever I am asked to judge an art exhibition, I look for a confidence in the application of the paint. Timid, unsure brushwork shows a lack of confidence. This exercise will encourage you to paint with a decisive stroke.

Place a simple object, such as an eggplant, in front of you. You may lightly sketch in the outline of the form. In this lesson, you will re-create the form with two strokes of your brush. To do this, dampen the background with clean water. Stay at least a quarter-inch from the edge of the eggplant yet to be painted so that area remains dry. Next, create a hard edge along the top of the eggplant by dragging your paint-loaded brush along its dry upper edge. The hard edge will define the form, while the upper edge of the brushstroke will soften out into the wet paper. Use one decisive stroke, and do not go back to add another stroke.

When the background is beginning to dry, release a drop of clean water above the soft edge of color. This will create a bloom and add a natural diversion from the hard and soft edges. It is a ruffled edge that occurs without any additional brushstrokes. Let the background dry.

Paint the eggplant with clean water only. Drag a no. 9 round brush loaded with violet along the bottom edge of the vegetable to outline its lower form. Allow the paint to swim upward into the damp shape. Do not add another stroke. When this dries, paint the leaves. This minimalist method of brushwork is a refreshing approach to clean, confident color strokes.

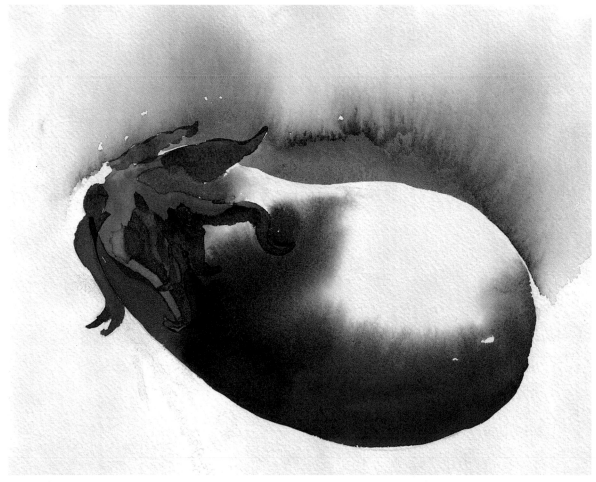

FINISHED EGGPLANT

APPLICATIONS & TECHNIQUES

Watercolors are extremely versatile. They lend themselves well to a wide range of textural effects. We can alter their consistency from a pale wash with a lot of water to a thickly applied opaque with very little water. They react, repel, slip, slide, mottle and merge. We are ever discovering new ways to extend the range of this medium. Experimental techniques require a willingness to take risks with your painting and expand on the textures you get if you use your paintbrush in the conventional ways. Experiment. Move beyond the normal safety of direct painting within the established rules. Add energy to your painting with an unusual textural effect.

In a step-by-step format, you will learn the most effective ways to paint frost or rain on a window, craggy rocks, old stone walls, lacey patterns, weathered wood, and foreground and background textures, to name a few. Remember, these techniques are meant to enhance your painting, not dominate it. Like anything else in life, too much of a good thing can spoil the lot. Use a special eye-catching texture only when it will add spark.

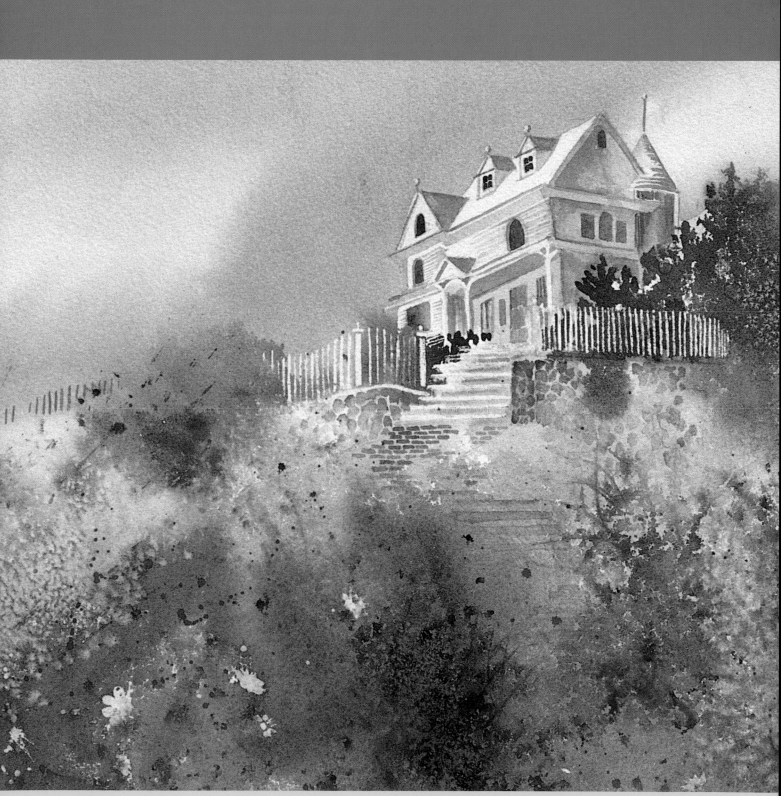

LAVENDER HILL
14" x 20" (36cm x 51cm)
Collection of Isabelle Bagnasco

Thirty Exciting Techniques

This chapter will help you explore and experiment with painting. It is exciting to see how the pigments and water are altered when various products are applied to them. Ordinary, everyday products can yield exciting new effects.

One day, I raided the kitchen looking for items that might cause some reaction with my paints. I tried coffee crystals; they stained the paper light brown, and I can get the same effect by glazing with varying mixtures of Daniel Smith Quinacridone Gold and Burnt Umber. Flour made a paste that is similar to an impasto medium, but it is not permanent and would eventually attract bugs! Egg whites gave no particular effect. Dish soap works well for a base with monoprint. It keeps the paint from beading up on the Plexiglas. I also experimented with cornstarch. Like soap, it works well for the monoprint technique. I even put a wet wash of color into the microwave to see what would happen to it (not much of anything, by the way).

Another time, I went to the garage to explore items that could change the texture or performance of my paints. I added acetone, turpentine and mineral spirits. Of these, I got the most striking results with the acetone. It created beautiful halos in the paint wash. A similar effect can be created by dropping rubbing alcohol onto a wash.

I also went outdoors to paint with nature, literally. I wanted to explore the technical possibilities of how auxiliary materials like leaves, twigs and sand would alter the expressive qualities of my paints. Some experiments were simply a waste of time, others were real disasters, but there were a few surprises. Those became sparks of exciting creativity in my paintings. For example, I found that I could impart an image of leaves and foliage by using a real leaf as a stamp. I can use the sharpened end of a twig dipped in paint to drag fine lines of paint or masking fluid across my paper. Small pebbles, shells or even flowers laid on a damp wash will leave interesting imprints and have viewers wondering how the painting was developed. These auxiliary techniques offer a contrast to painting done with a brush.

Unless otherwise mentioned, all of these techniques were done on Arches 140-lb. (300gsm) cold-press paper. Any technique that requires paint to be lifted, pushed aside or repelled works best with a nonstaining pigment. Nonstaining pigments lift off easier than staining pigments, and the results show a more striking contrast.

If you are looking for a fresh approach with your watercolors, try some of these unconventional approaches and materials.

TECHNIQUE REFERENCE CHART	
To create:	**Use technique number:**
Background texture	4, 5, 7, 8, 9, 11, 12, 13, 16, 18, 21, 22, 24, 27, 28, 29
Brick	12, 20
Bubbles	22
Clouds	7, 14
Crumbled walls	3, 4, 7, 11, 12, 14, 16, 20
Falling snow	11, 12
Field of grasses	3
Fine lines	25, 26
Flowers	15, 22
Foliage	3, 4, 5, 7, 8, 9, 11, 12, 18, 28
Foreground texture	see "Background texture"
Frosty window	4, 29
Lace	24
Ledge rock	3, 7, 26
Rain on window	4
Rock	7, 11, 13, 16, 28
Summer trees (leafy)	5, 11, 12
Underwater patterns	6, 7, 13, 18, 22, 27, 28
Water (lakes, oceans)	3, 7
Weathered wood	3, 7, 21, 28
Winter trees (bare)	10, 25, 26

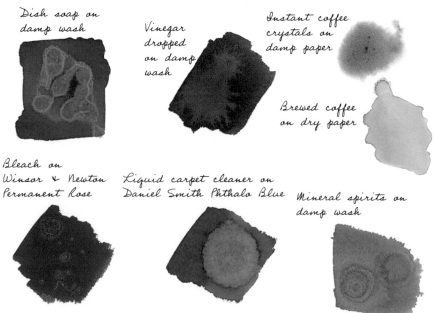

Dish soap on damp wash

Vinegar dropped on damp wash

Instant coffee crystals on damp paper

Brewed coffee on dry paper

Bleach on Winsor & Newton Permanent Rose

Liquid carpet cleaner on Daniel Smith Phthalo Blue

Mineral spirits on damp wash

Everyday items can create interesting effects with watercolors.

[1]
MIX A PROPER PAINT CONSISTENCY

[STEP 1] To realize the maximum potential of each pigment color, mix a pool of water and paint to a creamy consistency. Start by putting a small amount of water on your palette. Then add enough pigment to form a creamy mixture (not water, not milk, but a light cream formulation). Do not be afraid of bold color. Use it to enhance your paintings by attracting attention. If you use a pigment to its optimal capacity, you will not need to continue to overpaint in order to strengthen the color tone.

[STEP 2] There are, of course, situations in which you will want to alter the consistency of the paint to achieve special effects. For example, add more water to the mixture to achieve a paler wash. Add more pigment to create a heavy, possibly opaque effect that is good for drybrush.

TIP | *If you are working wet-in-wet (wet paint on wet paper), add slightly more pigment to your mixture since the color will be diluted by the water on your paper. Colors you put down on dry paper will lighten once dry. Colors put down on wet paper will lighten even more. So depending on the outcome you want, formulate your water-to-paint ratio accordingly.*

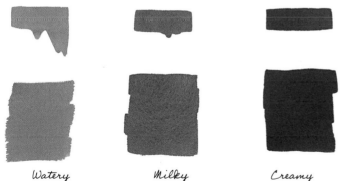

| Watery | Milky | Creamy |

PAINT CONSISTENCY

Creamy-consistency paint mixture

Thin-consistency paint mixture

| Wet on dry | Wet on damp | Wet on wet |

WATER-TO-PAINT RATIO

[2]
BRUSH AN EVEN WASH

[STEP 1] Prepare a large pool of paint. A light to medium consistency (milky to light cream) will be easiest to spread. Mix it well, and make sure you have enough to do the job, as you cannot stop in the middle of an even wash to mix more.

[STEP 2] Load your brush from the tip to the ferrule with a lot of paint. (Use the largest brush you can for the wash area in your painting. A sable brush will hold more paint and dispense it more evenly than a synthetic brush.) If you dampen your paper first, the brushstrokes will be easier to control. Just remember, however, that a wet-in-wet situation results in a paler wash once everything dries.

TIP | *It is helpful to work on a paper support that is slightly tilted up so that gravity will smooth out your wash.*

[STEP 3] Place your brush tip on the paper at an approximately forty-five-degree angle to the surface and drag it across then back again, zigzagging down the paper. Notice the bead of paint that forms at the bottom of each stroke. Be sure to pick up the bead with each additional stroke.

TIP | *If you keep your brush on the paper, you will minimize the drying time between strokes, therefore reducing the chance for streaking.*

[STEP 4] As you continue this zigzag down the wash area, drop the angle of your brush so that more of the brush is sweeping the paper. This will help the paint flow out of the brush onto the paper. If you are washing a large area and must reload the brush, do it as quickly as possible and continue the zigzag stroking. Do not be hesitant when working on this technique. A good even wash requires an aggressive brushstroke.

EVEN WASH

Zigzag strokes

[3]
DRAG A DRY BRUSH

Drybrushing is a useful technique for creating images of weathered wood, dry grasses, ledge rock textures, bricks, stones, even faraway mountain crevices. I use it with both paint and masking fluid. It requires a paint mixture that is heavier with pigment than the creamy consistency we generally use for most painting. There are two methods of application.

Application 1

Hold the brush, fully loaded with paint, at a forty-five-degree angle to the paper surface. Then lightly drag the tip of the brush across the dry paper, just touching its surface.

Application 2

Hold the brush parallel to the paper and drag the brush sideways across the surface. I get the best dry-brush results with this technique. You can drybrush over a dried wash and/or apply a wash on top of the texture once it has dried.

DRYBRUSHING: APPLICATION 1

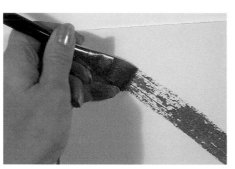

DRYBRUSHING: APPLICATION 2

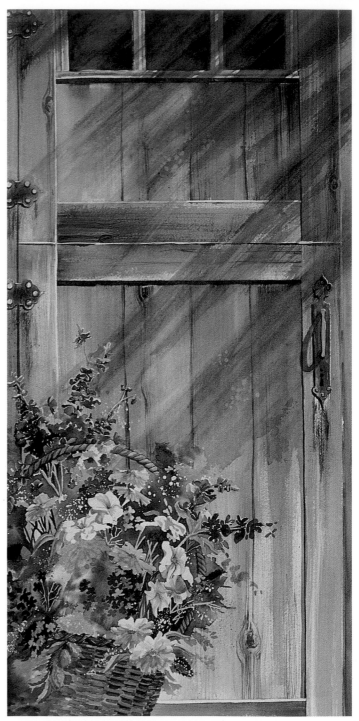

I used the dry-brush technique in three areas of this painting. After washing in a base color for the old wood door, I drybrushed a darker color over it to create a weathered wood grain. Next, I drybrushed to indicate rust dripping from the metal hinges. I also used it to pull shadows across the scene.

WELCOME
30" x 15" (76cm x 38cm)
Collection of Jerry England

[4]
Sprinkle Salt

Salt crystals repel pigment. They create an interesting texture when sprinkled on an even wash of watercolor. There are, however, a few tricks to getting the effect you want. Take a look at the different approaches to spicing up a window.

Approach 1: A Frosty Window

[STEP 1] Lay down an even wash of color. Watch the wash settle into the paper. Just as the wash begins to lose its shine, sprinkle on a few grains of ordinary table salt. You will not see a pattern immediately.

> TIP | *You will get a better effect if you drop the granules on sparingly, because each grain must have room to repel the color around it.*

[STEP 2] Wait until the wash dries. Brush off the salt grains and take a look at the pattern. If you want to bring the pattern out even more, scrub over the area with a clean, dry paper towel.

Approach 2: A Rainy Window

[STEP 1] Lay down an even wash of color. A dark, nonstaining pigment will yield a striking effect for this technique because the paint lifts away to reveal white paper. Staining pigments bite into the paper and, like a dye, are difficult to lift out. Just as the wash settles into the paper and begins to lose its shine, sprinkle on a few grains of table salt. Now hold the paper up at an angle so that gravity will pull the moisture down. Give the area a quick spray of water from a pump spray bottle; use one that has a forefinger pumping mechanism on the top of the bottle. It will broadcast a field of individual droplets.

Individual droplets of water from the pump sprayer must hit individual grains of salt for this technique to work. As the salt reacts to the water, it repels the paint, and the result is a fluid drizzle running down through the color wash.

> TIP | *Avoid fine-mist sprayers such as hair spray bottles; the droplets are too small and too close together. Also avoid a trigger-type sprayer; it shoots a stream of water that is too powerful for this effect.*

[STEP 2] Continue to hold or prop the paper up at an angle until it dries. Scrub the area with a clean, dry paper towel to brighten the effect.

> TROUBLESHOOTING | *If you are having trouble, check the consistency of your paint. Is it too thin? Is it too heavy? Are you using a staining color? Are you sprinkling the salt on too soon or letting the wash dry too much? Are you dropping on too much salt? Remember, less salt is better for this technique.*

SALT ON A WASH

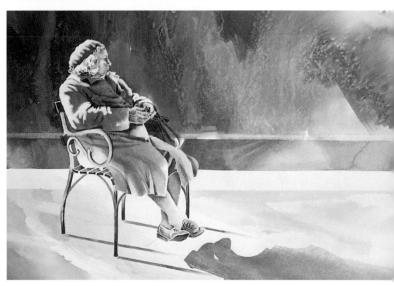

I wanted the design and mood of this subject to dominate, so I eliminated all background matter. The textural pattern behind the figure is nondescript yet interesting in its movement. I used the salt technique with clear water spray.

WAITING
12" x 17" (30cm x 43cm)
Collection of the artist

[5]
TEXTURE WITH A PUMP SPRAYER

I use a spray bottle for almost every painting I do. As a method of wetting my paper, I spray to wet the surface instead of using a brush or sponge, which would depress the surface fibers of my paper and reduce transparency. That is especially important when glazing, because I want light to refract off of each fiber of the paper's surface. Use a pump sprayer for this technique.

[STEP 1] Hold the bottle approximately ten inches (25cm) from the paper, spray once, spray again and continue until the individual droplets just begin to merge.

[STEP 2] Load a brush with paint of a creamy consistency. Saturate the brush until paint drops freely from the tip. Touch the tip onto the top of one of the droplets of water on your paper. The paint will swim from one drop to the next, invading the entire spray pattern. Tip your paper to help the paint run if needed.

> TROUBLESHOOTING | *Practice with your pump sprayer to determine at what distance from the paper you get the best pattern of separate droplets. Try a spray pattern on a counter or a piece of Plexiglas so you can see the droplet design. If you hold the sprayer too close to the surface, the droplets will merge into one pool. Hold the sprayer about ten inches (25cm) from the surface and deliver a confident pump. Repeat this spraying until each droplet is heavy with water.*

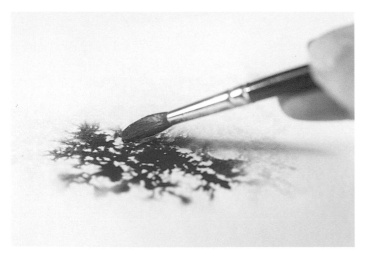

Touch the tip of a loaded brush to a droplet of water. To see this technique in a finished painting, look at the foliage in *The Gardener* on page 68.

[6]
PAINT THROUGH CHEESECLOTH

[STEP 1] Cut a piece of cheesecloth, and lay it out in a single thickness. Stretch and pull the threads into long strands, creating holes and tangled fibrous clumps.

[STEP 2] To confine the texture to a given area, tape or mask off any spaces that are not to receive patterning.

[STEP 3] Lay the fabric down on dampened (not wet) watercolor paper, arranging a design of the connective pattern of strings. Mist the entire sheet and the fibers with clear water to hold everything in place. Now add color. Use a large, soft mop brush to move the color over the threads. Be careful not to move the fibers as you add the paint.

[STEP 4] When everything is completely dry, remove the fabric.

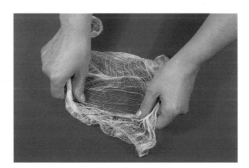

Stretch and pull cheesecloth into an interesting pattern.

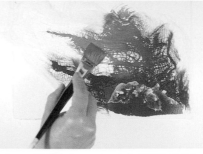

Add color. Here, I masked out a leaf pattern before applying the cheesecloth technique.

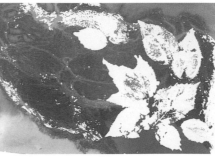

Let dry. Remove the fabric and see your exciting pattern.

[7]
IMPRINT WITH PLASTIC WRAP

Ordinary kitchen plastic wrap creates interesting effects when it is laid on a color wash.

Application 1: Gather and Stretch

[STEP 1] Cover any areas of your painting that you do not want textured by the plastic wrap technique. Use masking fluid to save those spaces. You can also save them by simply covering them with paper towel.

[STEP 2] Cut a piece of plastic wrap that is larger than the area you want textured. Gather it first along one side, then along the opposite side. Stretch it tightly apart.

[STEP 3] Lay it down on a wet wash of color. Tape the gathered edges down to prevent the pattern from moving. Allow the wash to dry.

[STEP 4] When the paint is dry, remove the plastic wrap and discover a unique and natural pattern that can be used for waves, wood textures, stratified cloud layers and furrows in ledge rock.

Application 2: Crumple

If you crumple plastic wrap and press it into a wet wash, you will get a fractured patterning of shapes.

[STEP 1] Lay down a nonstaining wash of color. While it is still wet, lay the scrunched plastic on it.

[STEP 2] Press and hold it down with a weight until the paint is dry. This is a nice effect for floral backgrounds, rock texture and distant mountains.

Tightly stretch the plastic wrap across the area you want to texture.

Press the crumpled plastic wrap into a wet wash.

This unique pattern can be used for waves, wood textures or stratified cloud layers.

Use this effect for floral backgrounds, rocks and distant mountains.

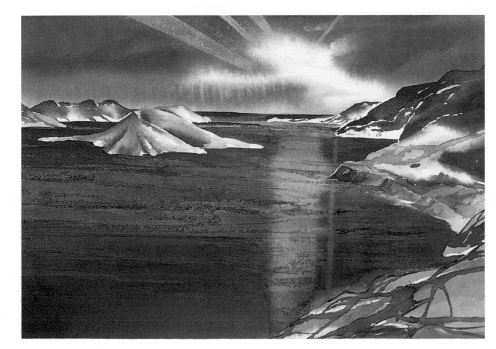

When I was on location in Santorini, I began a painting of the islands amidst the blue Aegean Sea. I wanted a dramatic effect for the water. First, I covered the islands with masking fluid. Then I chose an intense mixture of French Ultramarine for the sea and used the stretched plastic wrap technique. When the paint was dry, I removed the plastic and had an image of distant waves on the sea.

SANTORINI SUNSET
10" x 14" (25cm x 36cm)
Collection of the artist

[8]
USE NATURAL OBJECTS TO FORM A STAMP

I like to paint my own greeting cards, and whenever I can, I bring nature into my work. Stamping with leaves works well and is an easy way to create natural looking impressions without having to paint every tiny vein.

[STEP 1] Find a leaf with a prominent veining pattern on the back. Add color to the vein side of the leaf.

> **TROUBLESHOOTING |** *If the leaf has a waxy surface, paint a thin layer of dish soap on the underside. It will help the paint adhere and not bead on the leaf. Paint over the soap on the underside of the leaf with one or more colors. Analogous colors work best because they will not merge into muddy tones, but will blend naturally into each other. A creamy consistency will produce a good imprint.*

[STEP 2] Turn the leaf over and place the painted vein side down on your paper. Press it down with a clean folded paper towel.

[STEP 3] Lift the towel and leaf from the paper. I usually paint in some areas of the imprint with clear water so that the lacey texture is not overwhelming. Touch up any points on the leaf design that need refining, and add a stem.

Paint color on the vein side of the leaf.

Gently lift the leaf from the paper.

[9]
USE NATURAL OBJECTS TO FORM A STENCIL

This technique has a glazed, layered quality.

[STEP 1] Place a real leaf on dry watercolor paper. With a clean brush, dampen the paper one-half inch (1cm) out from the edge of the leaf. Do not dampen the paper right next to the leaf, or the color you paint on will bleed under it.

[STEP 2] Hold the leaf down. With your brush (a large flat works well) loaded with color, paint over and out from the center of the leaf into the dampened area. Use a heavier consistency of paint so that it does not run back under the leaf's edge. The paint that touches the dampened area will feather out to a soft edge, while the paint that runs over the leaf's edge will form a hard edge.

[STEP 3] Pick up the leaf and let the entire area dry. Once dry, you can repeat the process with the same or another leaf and the same or another (analogous) color of paint. Build up a foliage pattern in this way. I use this technique for backgrounds and like to combine it with the stamping technique.

Paint over and out from the center of the leaf into the dampened area. Remove the leaf and let dry.

Use this technique to build a foliage pattern.

[10]
BLOW THROUGH A STRAW

I live in Minnesota and see beautiful trees in every season. In the summer, the deciduous trees are full with their green leafy foliage. In the winter, the bare branches of birch, popple and oak are a linear contrast to the towering evergreen pines. To paint bare tree branches that have a natural look, I often use a straw to blow the paint into angular branch formations. Most trees have twigs and branches that grow at an angle to each other. Twigs grow smaller in size and are more plentifully at the top of the tree.

[STEP 1] To mimic this appearance, paint the tree trunk and a few of the main branches up the middle of the tree. Working on dry paper, drop a great amount of paint onto those branch lines. You actually want to see a bead of paint sit up on the paper.

[STEP 2] Next, place one end of a straw very close to the branch lines and give a mighty blow. (I like the straws that have a bendable section, because they are easier to manipulate.) You can drive the spurts of color in various directions by changing the straw's position for each blow. It is surprising how many offshoots you can get from one original branch line. Short, powerful bursts of air work best and produce an intricate pattern of tiny twigs.

Paint a few main branch lines. Use an excessive amount of very wet paint for these lines.

Place your straw close to a branch line and blow.

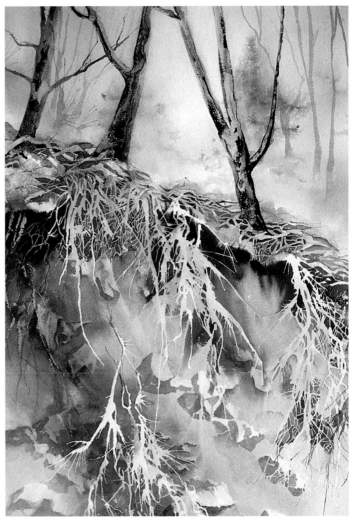

After laying down the initial wash of colors for this painting, I used masking fluid to indicate a few of the tangled roots that cascade down the crest of the hill. Then, with a straw, I quickly blew the masking fluid at angles down the hillside to form a web of root growth. The natural looking roots form a design centerpiece for this painting.

CRESTLINE CASCADE
28" x 21" (71cm x 53cm)
Collection of Kay Boyd

[11]
SPATTER WITH A PAINTBRUSH

[STEP 1] Load a paintbrush with paint of a creamy consistency. (A no. 9 round Kolinsky sable works especially well, but any natural-hair brush will work.) Hold a pencil or a small stick parallel to and approximately two inches (5cm) from your watercolor paper.

[STEP 2] Strike the loaded brush down onto the stick.

TIP | *Take care not to pull up from the strike too quickly. If you do, you will find the lovely spatter pattern continued on the wall or floor in front of your work area!*

[STEP 3] Drop the brush down on the stick and stop the movement. Lift and strike down again. By spattering the droplets on the downward stroke only, you can control the field of spatter. Reload your brush when the spattered droplets become thin and tiny. Try using an analogous color for the reload.

[STEP 4] Enhance the spatter pattern by giving it a quick spray of clear water from a pump spray bottle. You can make the effect more prominent with more water sprays. I use this texture for foliage, floral images, backgrounds and foregrounds.

Strike a loaded brush onto a stick to spatter.

A quick spray of clear water will enhance the spatter pattern.

[12]
SPATTER WITH A TOOTHBRUSH

[STEP 1] Prepare a paint mixture of a creamy consistency. Dip an old toothbrush into the mix.

[STEP 2] Holding a pencil or other small stick approximately two inches (5cm) from and parallel to your paper, push the bristles of the toothbrush across the top of the stick and away from you. A fine spatter will fall on your paper. Repeat the process, always pushing the toothbrush away from you.

TROUBLESHOOTING | *Be careful to not overload your brush with paint, or you may find large drops falling onto the paper during the spattering process. If your paint mixture is too thin, you risk the same consequence. A heavier consistency will stay on the toothbrush and release a fine misty pattern.*

Try this same process with masking fluid instead of paint. Once the masking fluid spatter is dry, paint a dark sky color over it. When the paint is dry, remove the spattered mask with a rubber cement eraser. This will give you tiny white specks against a dark background. It works well for falling snow or starry nighttime skies. Using both the positive spatter of color along with the negative (masked) spatter in the same painting creates a unique contrast. Try this technique in floral paintings or perhaps to add interest to hillsides of grass or sand.

Spatter paint using a toothbrush.

Spatter with masking fluid. Apply paint over the area. Use this technique at random locations around floral paintings and for rock texture, rain droplets, stars in the sky, falling snow, etc.

[13]
PULL A MONOPRINT

[STEP 1] Mix paint to a creamy consistency. You may want to mix two or more analogous colors to enhance the effect of this textural technique.

[STEP 2] On a smooth surface (I use a sheet of Plexiglas), apply a thin coat of dish soap. Use a synthetic brush to spread it around on the surface.

[STEP 3] Pour or paint the colors onto the prepared Plexiglas in a random pattern.

[STEP 4] Lay dry watercolor paper right side down onto the Plexiglas. Press it flat, then peel it off. If you do not get a good pattern, reapply.

> **TROUBLESHOOTING |** *If your paint mixture is thinner than a creamy consistency, you may experience a softer, less definitive pattern. Add more pigment to the mixture. You might also try adding a cornstarch paste to your paints. It will promote a suction between the paper and Plexiglas surfaces, and that is what creates this fascinating texture.*

Try this same technique on dampened paper for a softer effect. Bristol board or hot-press paper encourage an especially distinct pattern of very fluid looking bubbles.

Pour colors onto the prepared Plexiglas.

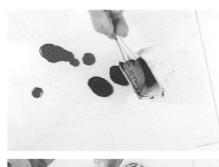

Peel off the watercolor paper and see the pattern you created. If you are dissatisfied, reapply.

[14]
BLOT WITH A TISSUE

I usually advise against dabbing into a wash with a paper towel or facial tissue. This may pick up unwanted color, but it also grinds some of the pigment into the paper, which reduces the overall transparency. However, I make an exception with this technique for forming natural looking clouds.

[STEP 1] Paint an even or graded wash (one that starts out dark in tone at the top of the paper then becomes paler as it progresses down the wash area). You will get the best results for this technique if you use a darker wash.

[STEP 2] While the wash is still wet, crumple a facial tissue and blot it into the wash. A hard blotting will give a very white cloud. Temper the blotting for paler clouds.

[STEP 3] Change the tissue formation with each blot, and change the size of each cloud for variety.

> **TIP |** *Do not press the same tissue formation more than one time. All clouds are different in size and shape. This is the key to the most natural effect of this technique.*

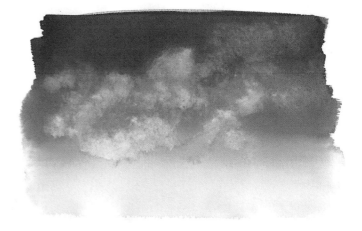

Blot the facial tissue into the wash. Remember to change the tissue formation to add variety.

[15]
PAINT A SHADOW

[STEP 1] In bright sunlight or under a very bright light, hold a flower, leaf or any object that has a distinctive shape you wish to paint. Flowers with a mass of leaf shapes work best.

[STEP 2] Place your watercolor paper below the flower and move the flower closer to the paper until you see a sharp cast shadow on the paper. Turn the flower. Tilt it. You will see interesting shapes forming within the shadows.

[STEP 3] When you find a shadow shape you like, hold the flower carefully in that position while you paint in the shadow shape with clear water. Use a lot of water.

[STEP 4] Next, drop analogous colors into the water. Color will run only where the water is. Allow the shapes to dry without interference.

> TIP | *The best results come from allowing the paint and water to mix naturally and dry on their own. Do not tilt or try to mix the colors. Let the colors swim on their own.*

Paint the shadow with clear water.

Drop color into the water.

[16]
TEXTURE WITH NEWSPRINT

Newsprint is quite absorbent. I have discovered that it leaves a vivid fractured imprint when pressed into a wash. It looks amazingly like the surface of jagged rock. This technique provides a natural looking pattern of light and shadow for sharp, split rock features.

[STEP 1] Lay down a wash of nonstaining colors. Using more than one color will give more exciting results, but remember to use analogous colors. Who said that rocks have to be gray or brown? Use beautiful colors for your rocks.

[STEP 2] Crumple a quarter sheet of newsprint. While the wash is still wet, press the newsprint into the color. Hold it down for about sixty seconds to allow the best absorption to take place.

[STEP 3] Lift off the newsprint. If you want more rocks, crumple the paper into a new shape and press it into the wash again. Once the wash has dried, add shadows to the areas behind and under each rock. To do this, use a darker shade of the color each rock was imprinted on.

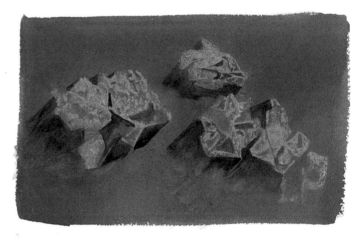

While the wash is wet, hold down the crumpled newsprint for about sixty seconds. Lift off.

[17]
CREATE A FOAM STAMP

I like to combine a realistically painted area or object with a less realistic, more illusionary image of the same subject. Sometimes I do this by painting both positively and negatively. Other times I use a product called Magic Stamp. It is a sheet of foam that when heated swells into a soft pillow.

[STEP 1] Hold the foam sheet over a kitchen toaster to heat.

[STEP 2] Press an object into the heated foam to create a reverse image.

[STEP 3] Using this as a stamp, paint color on it or press it into a pool of paint as you would an ordinary stamp.

[STEP 4] Press the stamp onto dry watercolor paper. You will get a natural negative image of the object you began with. This is an easy method to use to enhance your paintings with contrasting images. It will create interest and draw attention. It also promotes a depth of field since positive images usually appear to advance while negative shapes recede.

For a more intriguing impression of pine cones, I contrasted positive-painted ones with a negative foam stamp image.

WINTER
17" x 7" (43cm x 18cm)
Collection of the artist

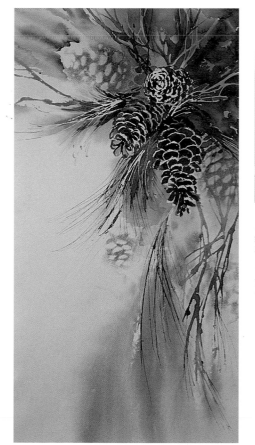

[18]
EXPLODE COLORS WITH FABRIC DYE

The color brown is made up of several colors. Of course, there are many shades and tones of brown, so the color combinations vary. But in general, if we mix the three primary colors—red, yellow and blue—with any of the secondary colors—violet, orange or green—we will get brown. This is the combination of colors that brown fabric dye is made of.

[STEP 1] Dip your watercolor paper into a tub of water. Make sure it is completely wet and there are no bubbles forming from the sizing that comes out when the paper is soaked.

[STEP 2] While the paper is very wet (dripping wet for this technique), sprinkle on a few grains of Rit Dark Brown powdered dye. This particular brand and color have the most distinct pigment granules, which separate and explode on contact with the saturated paper. Hold the paper up at an angle and watch the colors separate.

TIP | *A light sprinkle works best since each grain of dye needs room to bloom. If you dump too much on, you will see only a brown clump.*

Sprinkle a few grains of dark brown powdered dye onto wet watercolor paper. A light sprinkle works best.

Once the dye has put on its spectacular display, you can easily see the many colors used to make this color. I have used this technique for organic images such as forest foliage and underwater plant growth. The effect works well because it is completely natural. No brushwork is required.

LIFT PAINT

Each of these techniques works best on nonstaining color washes, but even a staining color will lighten if you use any of these methods of lifting paint.

I use the first approach most often when I need hard-edged lines. It works well for architectural shapes, but I have also used it to lift organic shapes.

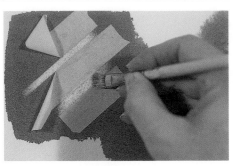

LIFTING PAINT
WITH A BRISTLE
BRUSH

Approach 1: Bristle Brush

[STEP 1] Lay masking tape on the areas around the shape you want to lift paint from. It is important to press the tape down securely in order to get a sharp edge.

[STEP 2] Wet the shape within the tape (that is, the shape you want to lift paint from) with clear water and allow it to sit for a minute to soften the paint.

[STEP 3] Using a small oil painting bristle brush, gently scrub the paint. Rinse your brush often so that you do not grind the old paint back into the paper, but rather loosen, lift and remove the color. When everything is dry, remove the tape to reveal sharp-edged white, or at least light, shapes.

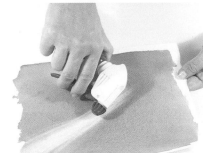

LIFTING PAINT
WITH A TRIGGER
SPRAY BOTTLE

This next technique is a good one for depicting rays of light. Using a trigger sprayer, you can spray a natural looking shaft of light from an area in a painting that has already dried.

Approach 2: Trigger Sprayer

[STEP 1] Hold the painting on its support board up at an angle.

[STEP 2] Adjust the spray nozzle to a medium fine stream, and hold the spray nozzle approximately one inch (3cm) from the paper's surface to help loosen the paint.

[STEP 3] Run the full force of the spray down the paper, moving the spray bottle all the way down the shaft of light. You may need to spray several times to achieve the desired lightness.

[STEP 4] To finish, wipe the light shaft down its length with a clean paper towel, always working at the same angle as the ray of light.

LIFTING PAINT
WITH A PUMP
SPRAY BOTTLE

When I want to break up an even wash area with a nondescript textural pattern, I use my pump spray bottle to lift paint.

Approach 3: Pump Spray Bottle

[STEP 1] On a dried, even wash of a nonstaining color, spray a pattern of clear water droplets.

[STEP 2] Allow them to sit for about one minute to loosen the paint under them, then blot with a clean paper towel.

[STEP 3] To really lighten the effect, quickly scrub the area with another clean dry paper towel. This is a good texture for foliage or to add interest to a floral background.

[20]
TEXTURE WITH A SPONGE

Approach 1: Stucco

[STEP 1] Lay down a soft wash of color.

[STEP 2] When the wash is dry, lightly soap up a natural sponge, dip it in a pool of masking fluid and tap it onto the dried wash. Allow this to dry, and rinse your sponge clean so that the masking fluid does not dry on it.

[STEP 3] Dip the sponge into a pool of paint, and tap onto the masked and washed area. Allow everything to dry completely.

[STEP 4] Remove the masking fluid. The area may need additional applications of sponged color. Sponge until you get the effect you want, but do not overdo the texture.

Approach 2: Brick

[STEP 1] Begin this technique by soaping up a natural sponge. Dip it into a pool of masking fluid, and lightly tap it onto your dry watercolor paper.

[STEP 2] When the mask is dry, lay a wash of color over the area.

[STEP 3] When that dries, load a large round brush (I use a no. 24) with a pigment mixture for the bricks. Lay the brush very lightly across the palm of your hand and allow the tip to roll over each brick to be formed upon the prepared wash. The brush will skip, paint and skip again over each brick. Avoid a heavy controlling hand. Allow the brush to hit and miss.

[STEP 4] When this application is dry, remove the masking fluid. Mix a paler version of the brick color now and repeat the brush-rolling process over each brick. You will hit some of the areas you have already painted as well as some of the previously masked areas.

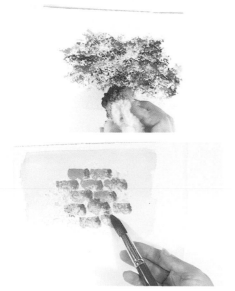

STUCCO
TEXTURE

BRICK TEXTURE

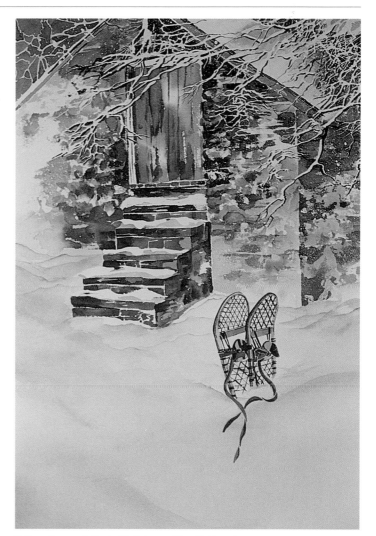

I dipped my palette knife into masking fluid and dragged in the bare branches and twigs of the trees. Then, I painted on the first layer of wash colors. Using the stucco and brick approaches, I developed the rock walls. Notice that some areas are more detailed and finished than others. I like the contrast of active areas and resting (or static) areas.

WINTER RETREAT
21" x 13" (53cm x 33cm)
Collection of the artist

[21]
CREATE PATTERNS WITH CORNSTARCH

[STEP 1] Mix a thin paste of water and cornstarch. Use an old synthetic brush to paint the mixture on your watercolor paper.

[STEP 2] Hold up the paper vertically and give it a quick spray of water.

[STEP 3] Pour a mixture of paint on or near the top edge of the paper and allow the paint to run down. When interesting patterns begin to form, lay the paper flat to dry.

> **TROUBLESHOOTING** | *If tiny rivulets do not form, check the consistency of your paint mix (it should be creamy). Also check the consistency of the cornstarch paste. If it is too thin, the paint will slide right over it. If it is to thick, the paint will not make inroads to form the tiny, hairline cracks that are characteristic of this technique. You do not want clumps of cornstarch stuck to your finished painting.*

PATTERN CREATED WITH WATERCOLOR AND CORNSTARCH

[22]
DRIP ALCOHOL ON A WASH

Like salt, ordinary rubbing alcohol repels paint. Apply it in the form of droplets falling on the paper. This action forces a unique pattern of rings to form. I use this technique for rock textures and lichen on rocks, as well as florals and abstract background and foreground textures.

[STEP 1] Prepare a pool of a creamy consistency of a dark, nonstaining color.

[STEP 2] Brush in an even wash, and while it is still wet but just beginning to lose its shine, sprinkle a few droplets of rubbing alcohol on it. Drop them from a distance of about ten inches (25cm) onto the wash. The characteristic ring each drop creates makes a natural soft-edged pattern for bubbles.

This unique pattern of rings can be used for rock textures and florals.

[23]
SPLASH WITH A TRIGGER SPRAYER

I use a trigger sprayer to lay down a river of water into which I drop color for a dramatic flow across my composition.

[STEP 1] Working on dry paper, hold the sprayer close to the surface, and aggressively sweep down a predetermined path. It may take three or four sprayings to create the effect you need. Some of the water runs in single streams down the paper.

[STEP 2] Notice the design the water makes, and adjust the sprayings accordingly. If you do not like the path it is taking, let the paper dry, and then retry.

[STEP 3] When you get an interesting flow pattern, pour a heavy concentration of color onto the water areas and allow them to run wherever they want. The paint will not travel outside the water areas.

TIP | *Because a lot of water is used, it is best to use a strong pigment. Remember, the color will fade as it dries.*

Sweep a path of water onto your dry watercolor paper using a trigger sprayer.

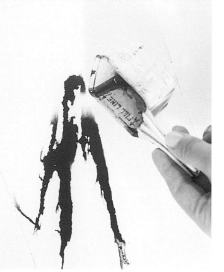

When you are satisfied with the flow pattern, pour on a color.

A trigger sprayer leaves a river of water that cascades down the paper. I often use this tool to create dramatic sweeps of color in my compositions.

BIRD OF PARADISE
12" x 7" (30cm x 18cm)
Collection of the artist

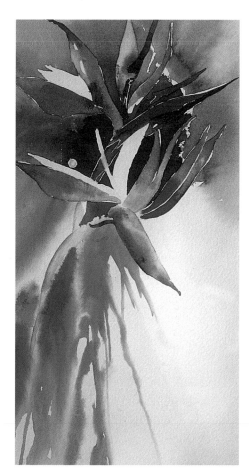

[24]
CREATE A LACE PATTERN

Instead of painstakingly painting in the tiny negative shapes within a piece of lace or a doily, I like to offer an illusion of lace.

[STEP 1] Lay a paper doily down on dry watercolor paper.

[STEP 2] With a large flat brush (a 1-inch [25mm] sable works great), dampen around the doily. Be careful not to come closer than one-half inch (1cm) to the doily's edge. If your paper is wet nearer than that, the paint may seep back under the doily, and the sharp pattern will be compromised.

[STEP 3] Using paint of a creamy consistency, pull the loaded brush across the doily, over its edge and out into the dampened area. The doily is made of very thin paper that disintegrates easily. Using paint that is too wet will saturate the doily. It will also flood under it. Some seepage can actually enhance an otherwise precise pattern, but too much will cause an unpleasant and confusing blotch.

[STEP 4] Pick up the doily as soon as you are done painting across it. This technique leaves a charming illusion of lacy curtains. I also use it with floral still-life paintings.

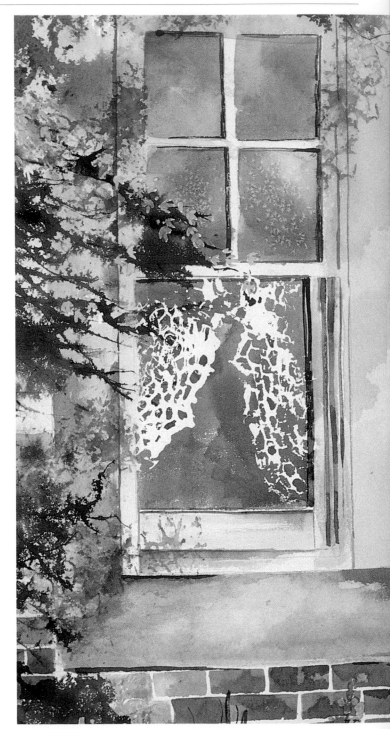

The impression of lace curtains was made with the paper doily technique. I balanced this intricate pattern with the salt effect on the windows and the spray technique for the foliage.

THE GARDENER (DETAIL)
28" x 21" (71cm x 53cm)
Collection of the artist

[25]
DRAW WITH A DIP PEN

At times you will need to make a very fine line. A rigger or liner brush will work, but you will have more control if you use a dip pen filled with watercolor paint. This tool works nicely for fine detail work. I keep a small, square-tip nib in my pen, and that affords clean, square-cornered marks and sharp edges.

[STEP 1] Mix a pool of paint to the consistency of milk.

[STEP 2] Load a small round brush (a no. 6 works well) with the paint and use it to fill the cavity in the pen's nib.

[STEP 3] Draw a few lines on a separate piece of paper to check for a good flow of paint to paper. If the paint is too thin, it will run out of the pen and spill onto your paper. If it is too thick, it will not flow out.

[STEP 4] To gain confidence with the dip pen, practice a series of horizontal, vertical and diagonal strokes. Try long sweeping strokes and curvilinear marks.

TIP | *Remember to not overuse the pen. It is easy to get carried away with detail. Fine lines and precise detail attract attention, so use them where they will be most appropriate to pull a viewer's eye.*

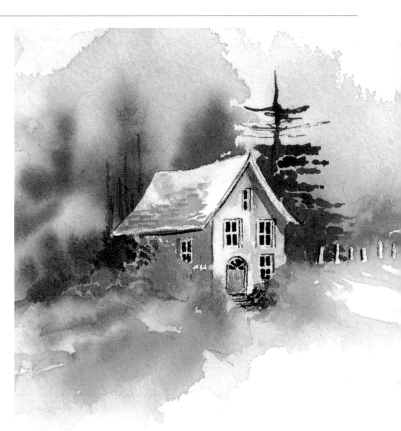

Fill the cavity in the pen's nib using a small round brush loaded with paint.

Tiny shapes, such as windowpanes and tree branches, often require fine delineation. Fill a dip pen with watercolor to draw these details.

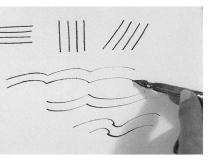

Check the pen's flow on a separate sheet of paper before using it on your watercolor paper.

SCRAPE WITH A PALETTE KNIFE

Variety makes a painting more interesting. Variety of colors, shapes, edges and techniques all work to draw the viewer's attention. I like to use a variety of applications as well as a variety of applicators to add excitement to my paintings.

A palette knife dipped into a pool of paint will drag a fine line across your watercolor paper. It can be very thin, a scratchy line, a full thick mark or a variegated line that goes from thick to thin. It is quite different from that of any brushstroke.

Approach 1: Scratching Out and Dragging Paint

I use my palette knife to pull tiny twigs out of the top of trees in my paintings. I scratch thin cracks in rocks with it. The knife I use most often has a small triangular blade. If I scrape the floor of my palette with the blade, I will pick up enough paint to pull a good line across my paper. Sometimes I use the broad side of the blade to scrape into a still-wet wash of color to highlight jagged rock formations.

Approach 2: Applying Masking Fluid

Try using a palette knife to apply masking fluid. Use the mask when dragging thin lines for birch branches. Then overpaint the area with a dark color. When you remove the masking fluid, the tiny twigs will stand out against the background.

Try using the broad side of the knife to apply masking fluid to the side of a mountain. After it dries, paint over it to form the mountain. When that dries, remove the mask, and you will see a natural looking snowy cascade down the mountainside.

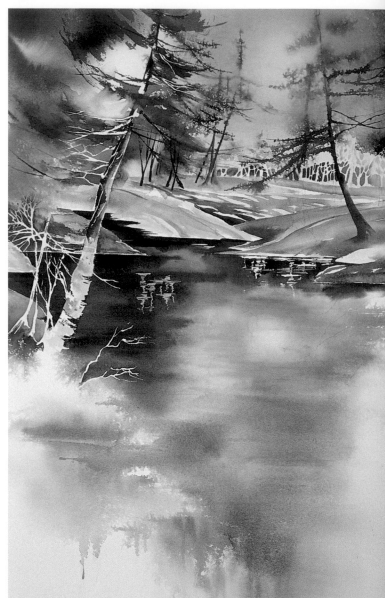

On the left side of this painting, I scratched out fine twigs and branches of trees with a palette knife dipped in masking fluid. I did that before I began painting, so that they would remain white against the dark water and foliage. On the right side, there are branches of pine dragged out with the palette knife, but here I dipped the knife into a pool of paint on my palette.

SUNSET ON DRIFTWOOD POND
28½" x 21" (72cm x 53cm)
Collection of the artist

[27]
TEXTURE WITH SAND

Sand and water create fascinating patterns in nature. We can re-create these same patterns on watercolor paper.

A smooth paper produces the best results, but I have gotten very interesting patterns with cold-press surfaces too. I stretch my paper unless I am working very small (a quarter sheet of paper). You may want to try this technique outdoors since it can get messy. If I do use it indoors, I work with the paper placed in a tray that will contain the water and sand as they slide off the paper.

[STEP 1] Sprinkle ⅛" inch (3mm) of clean natural sand (quartz) onto dry paper. Using a pump sprayer, lightly spray the sand with clean water.

[STEP 2] Hold the tray up on an angle to encourage gravity to pull the water and sand downward. Continue to spray until the sand is saturated and it begins to run in tiny streams down and off the paper.

[STEP 3] When you are satisfied with the pattern, lay the paper flat. You can now decide whether you prefer a soft image or one that has a more definitive pattern. If you want a softer texture, pour paint onto the sand while it is still quite damp. For a pattern with stronger color and harder edges, wait until the sand dries. You may decide to apply a soft texture first, resand the paper, let it dry and pour paint onto the paper again for a hard-edged imprint over the soft one. When you get the effect you want, you can develop it further by creating an image out of the pattern.

Use a pump sprayer to lightly spray the sand with clear water.

Pour paint onto the damp sand for a soft image. For a stronger color, wait until the sand dries.

This painting began with the sand technique. In this case, I did not encourage the run of tiny streams of sand down the page. I wanted a softer texture, so just as the sand and water began to slip down the paper, I poured on two analogous colors of paint. Later, I developed fish images. I asked myself if I would have created this interesting pattern of light and dark shapes or the unique texture if I had planned a painting of swimming fish. I imagine a pre-planned painting would look quite different. I like the fresh, natural quality of this simple painting.

SCHOOL'S OUT
7" x 11½" (18cm x 29cm)
Collection of Mr. and Mrs. Jamie Wagner

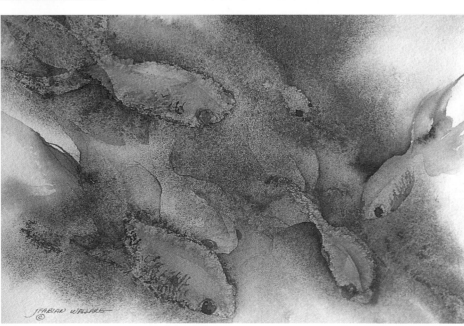

[28]
PATTERN WITH CHARCOAL

Powdered charcoal slides off of a pool of water, but it adheres to dry paper. The result is a very organic texture. I have used it to texture rocks, to bring interest when painting a forest floor, to add a weathered grain to wood. I have added it to foregrounds, backgrounds and brick walls.

[STEP 1] Onto dry watercolor paper, sift (I use a small kitchen sifter) a light coat of pure powdered artist's charcoal.

[STEP 2] Spray the area lightly with your pump sprayer. This will help "set" the texture.

[STEP 3] Now, rinse off the entire paper with clear water from a gentle sprayer or in a sink. Let the paper dry, and assess the pattern. You can repeat the technique for more texture. If you lightly spray the area with a clear acrylic fixative, it will prevent smudging.

> **TIP** | *If you spray or paint clear water on the paper before sprinkling on the charcoal, you will notice that no charcoal adheres to those pre-wetted areas. This is a way of corralling the powder into one specific area of your painting.*

Sift a light coat of artist's charcoal onto dry watercolor paper.

Spray the area with a pump sprayer to set the texture. Rinse the entire paper with clear water and let dry.

[29]
FREEZE WATERCOLORS

When snow or sleet freezes on your windows, frosty, feathered patterns form. You can capture the same effect with water and paint on your watercolor paper if you allow the liquids to freeze.

[STEP 1] Dip your paper into a tub of water, and lay it in a tray. If you are working very large, simply saturate the surface of the paper with water.

[STEP 2] Pour paint onto the very wet paper and leave it outdoors to work its magic. An outside temperature around 20°F (-7°C) is often needed for a frost pattern to form.

[STEP 3] Bring in the paper and thaw it out. When it dries completely, you can enhance the pattern by exaggerating the fractures with detailed brushwork.

Achieve frosty patterns by freezing your watercolors.

SIGN WITH A LASTING IMPRESSION

The final stroke of an artist to his work is the signature. It is an important part of the creative process and should not be a casual afterthought. Your signature will live with your work for its duration. It gives value to art.

Evaluate the placement of your signature within your painting. Also, consider the style with which you make your mark. Size is a factor; a signature that is too large will distract from the art.

Approach 1: Dip Pen

This method works best if the signature area is white or light in color.

Choose a color that coordinates with the signature area of the painting, and load a dip pen with watercolor paint. Sign your name with the dip pen.

TIP | *Signing your name with a staining color ensures a permanent image.*

Approach 2: Imbedded Imprint

Choose this method for a signature in a white or light area of your painting.

[STEP 1] Wet your paper with clean water in the area you choose for your signature.

[STEP 2] Onto the dampened area, brush a stroke of nonstaining color (preferably one that continues the color scheme of the painting).

[STEP 3] Using an ordinary ballpoint pen that is empty of ink, quickly sign your name.

[STEP 4] Rinse or spray off the stroke of color, and you will find your signature is permanently imbedded into the paper in a color that complements the painting.

Approach 3: Graphite

Many artists choose to sign their names in graphite. It is unassuming and does not distract from the painting.

Use a regular soft-lead pencil. This is not a permanent method as the signature could be erased.

TIP | *When I use graphite, I sign with a heavy hand so that the mark is pressed into the paper.*

Approach 4: Waxed Paper

If I am doing a painting that has a lot of dark color in the area of the signature, I plan ahead and employ a method that will allow my name to show through the deep tones.

[STEP 1] Before beginning to paint, lay a piece of waxed paper onto the watercolor paper in the signature area.

[STEP 2] With a ballpoint pen or other sharp point, write your signature, pressing down through the waxed paper. A heavy pressure assures that the wax will transfer onto the watercolor paper.

[STEP 3] Later, when you paint over the area, the wax imprint will show through.

Sign your art using a dip pen.

Permanently imbed your signature into the paper.

Sign with graphite.

Use waxed paper to sign your work.

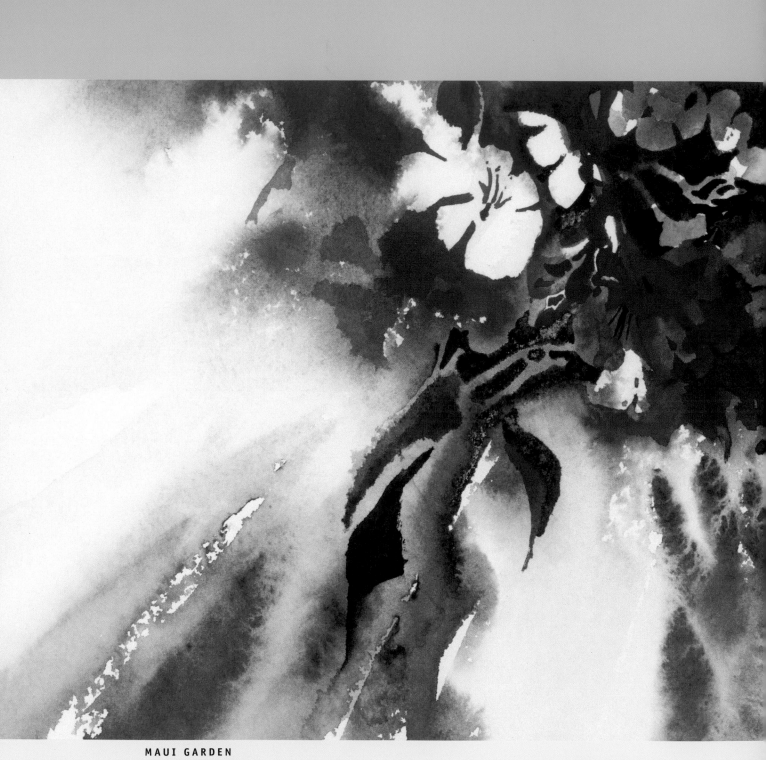

MAUI GARDEN
6" x 10" (15cm x 25cm)
Collection of Mary Hertog

I remember the first time I got excited about a watercolor
painting. The free-flowing images in a painting of an Indian
caught my interest. It was the way
the subject was painted that fascinated
me. Although I had a degree in fine art
and had worked for years as a graphic
designer, I had never painted with watercolor. I became
determined to learn as much as I could about watercolor
painting.

GLAZING

I love the fluidity of the medium. It has life. It is
unpredictable at times, but that is the most exciting part.
It is a challenge and, as with my golf game, I never tire of
the desire to improve.

I have now spent years painting, and there has been
a steady progression toward giving up control to the
medium. It has not been a conscious effort, but rather it has
developed as a natural maturing of my own artistic outlook.
The more I have allowed the paint and water to do the work,
the more satisfied I have been with the results.

What is Glazing?

Glazing is the ultimate end in the quest to loosen up. When we allow water and pigment to swim freely across our watercolor paper, we are really embracing the unique unpredictability of watercolor painting.

Glazing is a method of overlaying transparent layers of pigments. Watercolors lend themselves particularly well to glazing. If we layer transparent, analogous colors of paint, the effect is an incomparably smooth, glowing light that is unique to this medium. You can use glazing at the beginning of your painting in the first wash of color or during the process of developing your image. You can glaze color over parts of the finished painting to add atmosphere, to light up the scene or to simply tone down a secondary portion of the picture.

There are many methods of glazing. You can use a brush to lay down one color, then when it has dried, brush another color over it. For example, if you paint an area with blue (primary color) then overpaint with yellow (primary color), you will have an interesting green (secondary color). It will be a more exciting green than if you use a green pigment from a tube. You might continue to layer other blues and yellows to develop a deeper green. However, this method of layering colors with your brush has a distinct disadvantage: Each time your brush sweeps across the paper, it depresses the tiny surface fibers that refract light. It also grinds some particles of pigment into the paper. These two very important factors diminish the overall transparency of the glaze.

DEMONSTRATION

POUR A GLAZE

In order to retain the pristine conditions of the paper and to get the ultimate glow from a glaze of color, eliminate any unnecessary contact with the paper surface. Pouring is the most unobtrusive way to apply color. It preserves the pristine condition of the surface fibers. This is important for the maximum intensity and transparency of your glazing. Those tiny surface fibers refract light, and they can do that best if they are left standing.

[STEP 1] Wet the Paper
Using a pump sprayer, saturate your paper until there is a complete sheet of water on it. The pump sprayer eliminates the need for dragging a brush or any other device across the paper. Check the overall wetness of the paper by tipping the sheet up to the light. Watch to see if the water runs off in a sheet. If it catches on a dry spot, spray that area again. Then run off the excess water. The paper should be wet, but there should not be any standing pools of water.

[STEP 2] Mix the Colors
In separate cups, mix transparent colors to a light creamy consistency (I use the plastic cups included in boxes of laundry detergent).

[STEP 3] Pour the First Color
Gently pour a manageable amount of one color onto your damp paper. The color should easily slip across the surface of the paper. Tilt the paper to encourage the paint to swim in a direction you choose. You can guide the color, but do not try to control the flow. The beauty of this process is the free-flowing quality.

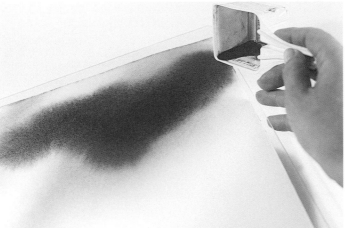

[STEP 4] Re-Wet and Continue Glazing

You could pour on another color now, but I recommend that until you are comfortable with glazing, you take time to assess this first glaze. Let this first layer dry, re-wet the paper and then pour your second color. If, for example, you want a glowing pink-orange sky, pour Winsor Yellow, let it dry, re-wet and pour Winsor Red over the yellow. When that dries, evaluate the color and the glow. Maybe a glaze of Permanent Rose will heat things up. As long as you choose analogous colors (side by side on the color wheel), your glazes will be clear and radiant.

Gently pour another glaze of color.

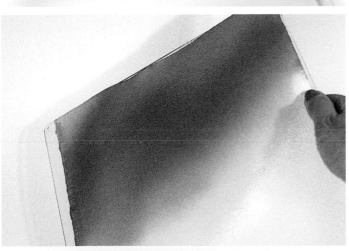

Tilt the paper to encourage the color to flow. Use analogous colors for clear, radiant glazes.

Finish

I glazed alternate layers of Winsor Red and Winsor Yellow on the sky. Finally, I glazed on a layer of Quinacridone Gold and continued to tilt the paper toward the upper right to create a movement in the flow of colors. In the foreground, I used the same glowing orange as the sky until the final stage of painting. It needed to be dulled a bit so that it would not pull attention away from the sky and birds. I glazed over the lower portion of the painting with blue to dull it slightly.

SEA WALL
16½" x 22½" (42cm x 57cm)
Collection of the artist

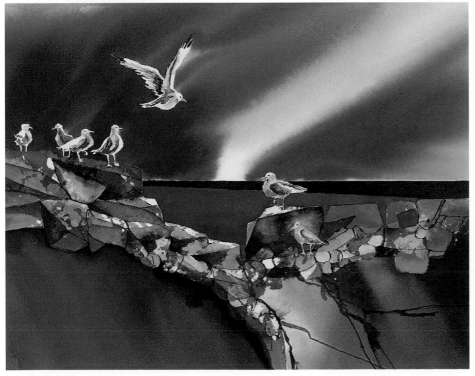

Three Stages of Developing a Painting

There are many methods of working with watercolor. You could delve right in and begin painting the various objects in your composition as you might with acrylic or oil painting, but if you do, you will miss the beauty of layering this beautiful transparent medium. Watercolors will glow with light if you glaze color on the paper.

Watercolor painting has an undeserved reputation for being a difficult medium. You need not be afraid of watercolor painting if you work in stages.

Stage One: First Wash

When you have developed a good composition and transferred the sketch to your stretched watercolor paper, you are ready to begin stage one: first wash. The first wash is the foundation for your painting. You will build, in stages, upon this base of color.

Now it is important to decide where you will save white spaces on your paper. These are areas of the paper where no color will be glazed on. Just a meandering of white spaces will enhance the lightness of the overall work. Without this light relief, a painting becomes heavy with color. Contrast between painted and unpainted areas makes a painting more interesting.

White spaces will also offer you an opportunity to add pure color on white paper later on. I usually save the area around the center of interest and then random paths of white areas leading out to two or three edges of the sheet. This allows me the freedom to choose later in the development of my painting if I want to paint or glaze clean color in the preserved areas. To keep designated space white when glazing, you will tilt the paper so that the colors do not slide over those areas.

You will need to consider a color palette for your painting. Begin at the center of interest. What is the dominant color? If you choose red, for example, then see on your color wheel that its complement is green (see page 26). If you surround the focal area with green, you will create the basis for a contrast in color that will attract attention to that area. Working out from the green, paint or pour analogous colors. For example, in a focal area of red roses, I would save a white space during my first wash so that I could later paint bright red flowers on the white paper. Around that white space, I might lay a wash of green, then as I move farther away from that area, I would glaze with blue, then violet. I could choose to go the other way (around the color wheel) and paint the green then yellow, then orange. Using a complement to the color of the focal area then continuing out to the perimeters with analogous colors will prevent you from forming muddy colors. Later in the painting, you can add glazes of other colors and paint in the complementary focal area colors.

You may, however, choose a strong value contrast to bring attention to the center of interest. In that case, you will determine whatever color you want nearest the center of interest and paint or pour it on first, then continue with analogous colors out toward the edges of your painting.

Stage Two: Separate the Objects

This stage is when the painting takes shape. During stage two, you will separate or define various shapes in your composition. That is, you will create hard or soft edges that will form distinct shapes, and you will strengthen the value intensity of some colors, especially those at the center of interest.

Placing the strongest contrast of the elements of design at the center of interest will pull the eye to that area. It also sets a guide for how intense the rest of the painting should be. As you move away from the focal area, value contrasts should begin to subdue, colors should move toward the middle tones, hard edges should start to soften.

In this stage, you might choose a special technique to add interest to your painting, and you might add glazes of color to sections of the paper.

Stage Three: Finish

The third and final stage of developing a painting is the finish work. This is the time to give a critical eye to the work. Step away from the painting and evaluate the qualities you have developed to this point. It is helpful to view it from a distance in order to judge the value contrasts. Is there an eye path? Is there a focus that draws attention? Are the colors harmonious, or do they fight each other?

Final glazes are helpful in harmonizing colors. Despite the best intentions, some paintings end up with less-than-desirable color mixes. If two or more unharmonious colors have come together on your painting, choose a middle color (one that lies between them on the color wheel) to glaze over the area.

STAGE ONE: FIRST WASH

The first wash was a series of yellow and red-orange glazes. I masked out the gate, some of the rock wall and a few trees. With the paper completely wet, I poured yellow onto the sky area and drained it off to one side. When that dried I glazed more yellow onto the foreground. Then I alternated glazes of red-orange and yellow across the top until the sky began to glow. I kept color from flowing near the gate, so I could later add a pure blue to that area.

STAGE TWO: SEPARATE THE OBJECTS

In order to attract attention to the gate, I applied a strong, deep blue wash across the low sky and behind the gate. It created a strong value contrast with the gate as well as a complementary color contrast with the orange upper sky.

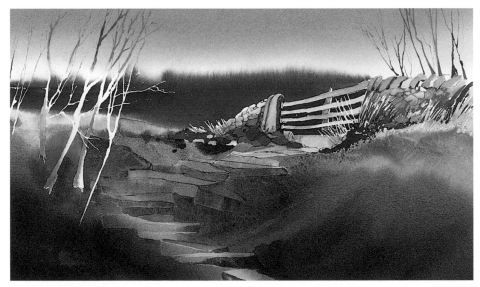

STAGE THREE: FINISH

In the final stages of this painting, I decided to glaze over the foreground in order to highlight the brilliant sky. Several layers of glazing were poured onto the lower area of the painting. Each layer was allowed to dry before the next one was applied. By dimming the foreground, I was able to ignite an intense glow in the sky.

COUNTRY GATE
11" x 19" (28cm x 48cm)
Collection of the artist

DEVELOP AN IMAGE OUT OF A GLAZED WASH

Stage One: First Wash

A first wash is an exciting part of the painting process. It establishes a color palette, creates a directional flow for the composition and lays a foundation for whatever subject you choose to develop.

I have a choice between composing my subject and then glazing the first wash accordingly or simply pouring on colors and then searching for a subject. In this demonstration, I have decided to do both. The subject will be floral, but I will work with whatever I get in the initial glazing. There will be no preliminary sketch. This is an exciting way to loosen up with your watercolors.

> **MATERIALS LIST**
> - Arches 140-lb. (300gsm) cold-press paper (quarter sheet)
> - Paper support (Plexiglas, Homasote or wood board)
> - 4 pouring cups (I use the plastic measuring cups from laundry detergent boxes)
> - Pump sprayer (finger pump on top)
> - Trigger sprayer (with trigger nozzle)
> - No. 6 round sable brush
> - Daniel Smith watercolor:
> ~ Carbazole Violet
> - Winsor & Newton watercolors:
> ~ Cobalt Blue
> ~ Hooker's Green
> ~ Permanent Rose
> ~ Permanent Sap Green
> ~ Quinacridone Magenta

[STEP 1] Glaze on the First Wash Colors

To prepare for the first wash, wet the paper by spraying clear water onto it with a pump sprayer. Use a pump sprayer so that the force of the spray will not damage the paper's surface fibers. Be sure the surface is completely wet but has no standing pools of water. Tilt the sheet up on an angle. Does the water slide off easily without catching on a dry spot? If not, spray that area with more water and again tilt to drain off the excess.

[STEP 2] Mix the Pouring Cups of Color

Mix a pouring cup of Cobalt Blue, one of Permanent Sap Green with a little Cobalt Blue and some Hooker's Green in it, one of Permanent Rose with a bit of Quinacridone Magenta in it, and one of Carbazole Violet. These colors are analogous (i.e., side by side on the color wheel): green, blue, violet and red. Using analogous colors helps you avoid dull or muddy areas where pigments merge together.

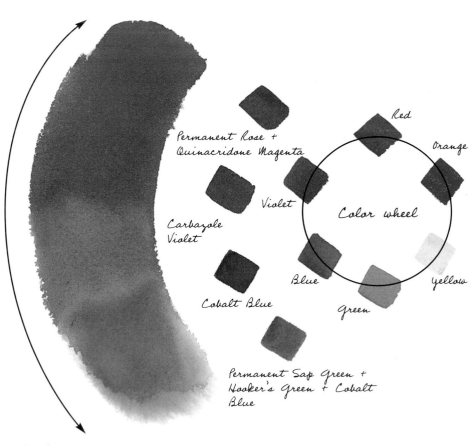

Permanent Rose +
Quinacridone Magenta

Violet

Carbazole
Violet

Red

Orange

Color wheel

Blue

Yellow

Cobalt Blue

Green

Permanent Sap Green +
Hooker's Green + Cobalt
Blue

Analogous colors

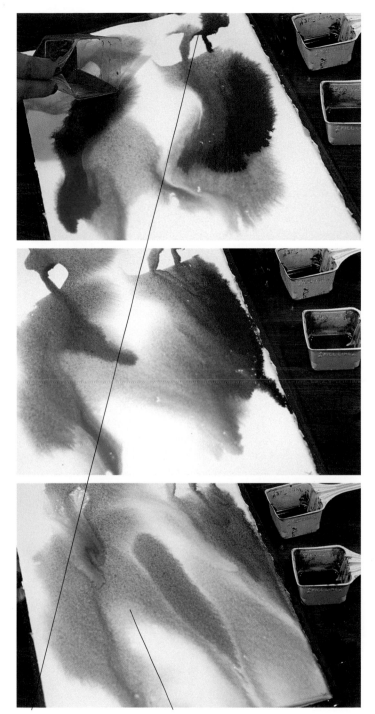

Hard edges Soft edges

[STEP 3] Pour a Wet-in-Wet Wash

Respray if the paper has begun to dry. Pour the colors on the dampened paper one by one in an analogous order (not on top of each other, but side by side). Remember to preserve some white spaces. Tip the paper up to allow some of the paint to run down the page at a diagonal. This starts to develop an eye path in the painting.

This first wash of colors has a good pattern of color shapes and white spaces that gives an airy quality. Solid color would have been too heavy and limiting. Notice how the first wash paled once it dried. Those vibrant wash colors were poured onto wet paper. That doubled the amount of water normally used with ordinary direct painting. When glazing wet-in-wet, you disperse the pigments in twice the amount of water, so the creamy consistency of the paint mixture is diluted. Also, as you tilt and move the glazed color around, some pigment runs off the paper. This is a good base upon which to build this painting.

FIRST WASH RESULTS

Notice the hard edges at the top. Normally I would re-wet and merge these into soft edges, but I am intrigued with the pattern they have created, so I will try to work them into my design.

Also notice the blue I poured between the green and violet has been lost. This happened when I tipped the board to encourage the colors to mingle. Green and violet should be separated by blue to be analogous. I could spray that area and repour blue in between the nonanalogous colors. I must make a decision quickly before things dry. The colors have not muddied, and they are muted in tone, so they are not attracting attention. I will leave the wash as it is.

Stage Two: Separate the Objects

Once the color foundation is set, it is time to develop the shapes. Use the first wash colors as your base; where there is a Permanent Rose glaze, create a flower shape using a darker shade of that same Permanent Rose color. Where there is green glazing, develop flowers using a darker shade of that same green. You can overpaint an analogous color of what was put down in the first wash, but do not stray too far from the initial colors. For example, if there is a blue area in the first wash, you should paint objects in that area blue. You could use blue-green or blue-violet to paint an object within the blue wash, but be careful to match the warm or cool temperature of the original blue wash, and do not attempt to stray beyond blue's analogous colors. If you do, the colors will become muddy and dull. Keep a color wheel by your worktable for easy reference.

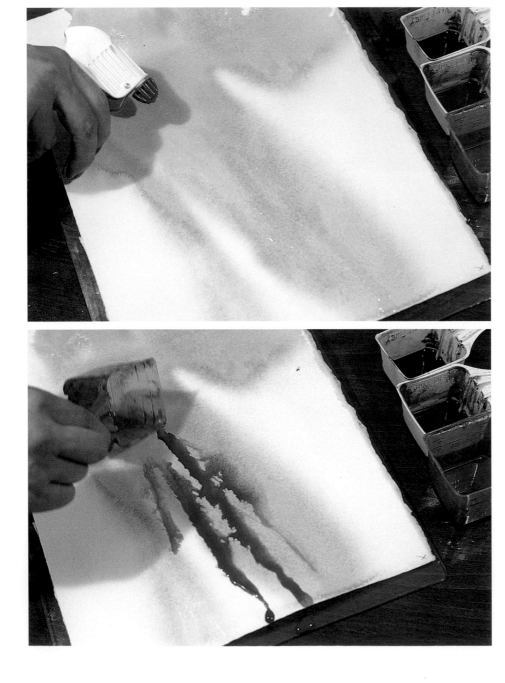

[STEP 4] Spray a Base for the Foliage

Use a trigger sprayer to create a dramatic diagonal sweep as well as an impression of draping foliage. The trigger spray technique (see page 67) is perfect for creating an abstract suggestion of leaves and stems. Tilt the paper and run the sprayer down the length of the diagonal. You may want to repeat the spray to achieve more streams of water.

[STEP 5] Pour Colors for the Foliage

When you are satisfied with the way the water is flowing on the paper, pour directly into the stream colors that match the colors put down in the first wash. Tilt the paper to run the colors down and off. If you are handy, you will be able to catch the dripping paint right back into its pouring cup. Assess the design of the flow. You might spray more streams of water to soften the effect, or you can wait until this pouring dries and repeat the process with the same or another color.

[STEP 6] Create Floral Images

Develop leaf and floral shapes by working in both positive and negative painting (see "Positive and Negative Images" in chapter five). That is, paint an object as it appears (positive), and in other areas paint only the spaces around and between objects (negative). Beginning at the upper left of the paper, paint a flower by radiating out a series of hard- and soft-edged petals. Vary the size and shape of each petal. Use the white space, preserved in the first wash, to create a white flower. As the flower shape flows into the green wash, continue painting with a darker shade of green.

Move to the upper-right area of the paper and form a magenta flower using a darker shade of magenta. When the flower spreads out into the violet wash, start painting that part of the flower in violet. Staying true to the colors of the first wash assures you of pure, clear colors.

[STEP 7] Enhance the Value Pattern

As you work, consider where you might add a dark value. Establishing a dark value pattern will add impact because it creates a contrast with the light or white areas. Placing the darkest dark next to the lightest light will attract the most attention. Add the darkest tone around the flowers at the focal point. Use a very dark shade of whichever first-wash color exists around those flower shapes. If one section is green, paint a dark area over it with a very dark mixture of that same green pigment. If it flows into a blue, paint a dark value of blue. Radiate the dark values from that area. Develop the very deep tones into a connected dark value pattern rather than isolated or individual dark spots.

Adjust the value pattern as needed and add more flowers. As you move away from the center of interest, offer less detail. The most detail and the strongest value contrast are at the center of interest. Images become less distinct and softer in value as they get farther away from the focal area.

Stage Three: Finish

[STEP 8] Add More Flower Shapes, Evaluate and Finish

Continue adding flower shapes. It is not necessary or even desirable to detail every flower. As you move away from the focal area, hint at floral shapes by painting them in softer tones and painting only a portion of the petals. In this way, you can create an illusion of images rather than a realistic portrayal.

The finishing stage is for the final touches only. Do not overwork your painting. Check for the overall balance of shapes and colors. Evaluate the dark and light value patterns. In this painting, I defined a few more leaves and refined parts of the lower flowers.

Glazing a first wash of analogous colors helps enhance the fluidity of the watercolors, and it establishes a transparent base for your painting. If in stage two you stay true to the original wash colors, you will maintain a color harmony. In stage three, you can add fine detail and/or a final glaze of color over parts of the painting to dramatize the light or tone down passages in the composition.

You may decide to add a final glaze. I do not choose to apply any more glazing to this piece because I like the placement of the white areas and do not want to change or darken any particular area.

ROSE GARDEN II
14" x 10" (36cm x 25cm)
Collection of Donna Kidd

MORNING SONG
16" x 22" (41cm x 56cm)
Collection of the artist

This chapter includes five step-by-step demonstrations. In
each of the following demos, we will work through a complete
painting. Five essential
contrasts will be
explored: warm and
cool colors, positive
and negative images,
hard and soft edges,
light and dark values, and illusion and reality. Each
demonstration uses glazes to harmonize colors, reduce
secondary areas and/or create a dramatic glow of light at
the center of interest.

STEP-BY-STEP
DEMONSTRATIONS

Warm and Cool Colors

The color spectrum is a marvelous array of brilliant colors. It is a joy for artists to mix the vibrant hues. But there is more to successful color choice than pretty pigments. Learning how to make the best use of your colors will allow you to create movement, indicate depth of field, evoke a mood, boost excitement, even cause a pulsating impression.

Color Temperature

Every pigment on your palette has a temperature. It might be warm or cool or somewhere in between. It is especially important for watercolorists to recognize the properties of the colors they use, since this medium often requires rapid application.

Look at the basic color wheel. It divides naturally into a warm side and a cool side. Red, orange and yellow are generally considered to be warm. Green, blue and violet form the cool side. Hues that appear to have more yellow in them are warm, while those that have more blue content are cooler.

There is, however, more to it than that. The temperature of any given color is actually dependent on its relation to the colors placed next to it. Color temperature can be altered by adjacent colors. A hue that appears warm when it stands alone may become cool when surrounded by warm tones. For example, Winsor Red is considered a warm color until it is placed next to an even warmer color, such as Cadmium Scarlet. The stronger warmth of Cadmium Scarlet dramatically changes our temperature perception of Winsor Red. In comparison to Cadmium Scarlet, Winsor Red is cool.

Atmosphere

Warm colors advance and cool colors recede. In a natural setting, distant objects become muted in tone and cooler in color temperature. The reason for this is that we view distant objects through progressively more atmosphere. That means we are looking through more dust particles and water vapor. Things far away become muted because dust and water vapor refract tiny bits of light. The distant objects are cooler in color temperature because water vapor reflects light from a blue sky. Conversely, on a cloudy, gray or foggy day, there is less definition between far and near objects; the atmosphere is saturated with water, and little sunlight gets through to bounce refracted light.

The interplay of warm and cool colors will create exciting interpretations of light and space in your paintings. By skillful placement of color temperatures, you can suggest clear, sun-filled environs; humid, moisture-laden air; or a dewy atmosphere.

Mood

Color is often used to offer a subliminal message of mood. For example, warm red is a fire and passion color, while cooler reds such as Alizarin Crimson emphasize a more somber, perhaps regal feeling.

Warm pigments are aggressive, inviting, alive, happy. Cool tones are more restful. They are used when the mood is mysterious, sad or calm.

The size and placement of color areas also affect the impact of temperature. A small spot of warm yellow within a large area of a cool color like Antwerp Blue will have more zing than equally sized areas of warm and cool tones. Because the singular, bright yellow color is unusual within the vast areas of blue, it becomes dominant. It will attract attention because of its uniqueness.

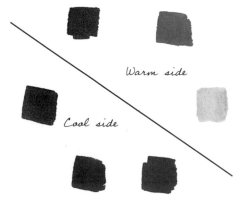

WARM AND COOL COLORS

Warm side

Cool side

COLOR CAN SUGGEST MOOD
Remember that warm pigments can suggest happiness and aggression, while cool tones can suggest calmness or sadness.

Depth of Field

Color temperatures are used by artists to create depth or distance in a painting. We can use cool colors to push areas of our painting back into the distance. Warm tones will make objects or spatial areas appear closer to the viewer. With selective temperature control, an artist can turn a dull, flat image into a vibrant series of planes that advance and recede. By using progressively stronger values of warm and cool colors, you will create a more dramatic depth in the spatial planes of your painting.

Movement

You can promote eye movement in your paintings by shifting pigment temperature. The interplay between warm and cool creates an attention-getting friction that guides a viewer around the scene.

✳
COLOR TERMINOLOGY

- *Hue* means "color." It relates to where a particular color is on the spectrum.
- *Pigment* is the physical substance of paint and describes a more specific formulation name. For example, Alizarin Crimson is not a hue but a specific formulation of a hue. Paints are often named for the mineral or chemical used to make them.
- *Tint* is a color with white added. In watercolor, we can tint a color with clear water and use the white of the paper as a lightener.
- *Shade* is a color with black or a dark color added.
- *Chroma* or *intensity* refers to the brightness or dullness of a color.
- *Value* is the relative lightness or darkness of a color.
- *Tone* is a mixture of a pure hue plus gray.
- *Neutral* means white, black or gray. These are achromatic hues.

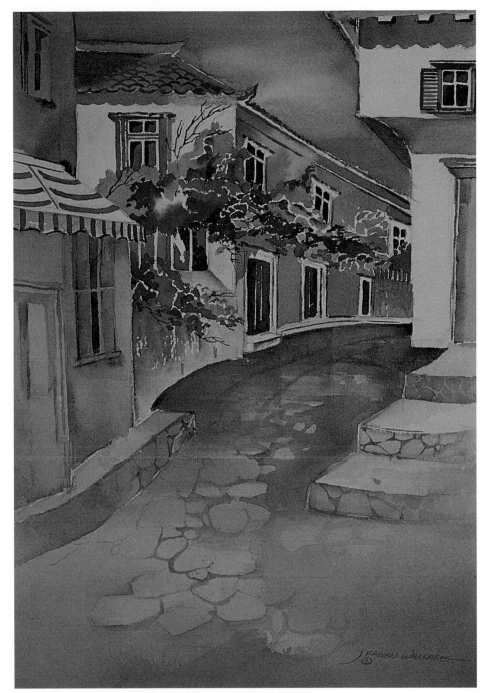

Warm colors advance. Contrasting cool colors recede. This painting was done on location at a workshop I instructed in Greece. It was quiet on this street, and I wanted to capture the serene mood. Violet and blue glazes in the shadows cooled down the hot, sunlit scene. I exaggerated the intensity of the shadows to dramatize their contrast with the sunstruck walls. I also glazed the foreground with warm tones to bring that area closer to the viewer. Cool tones in the background and warm tones in the foreground create receding and advancing planes. Atmospheric temperature changes between cool and warm areas generate eye movement and add interest to a painting.

VIEW OF HYDRA
14" x 10" (36cm x 25cm)
Collection of Joan Cimaglia

BEACHCOMBERS

In this demonstration, we will use contrasting warm and cool temperatures of color to create movement around the painting. We will warm the colors nearest to the foreground and cool the colors in the distance to suggest depth of field. Using a palette knife to draw fine lines of masking fluid onto the crests of waves and onto the seagulls, we will preserve these whites while pouring on a series of color glazes.

<table>
<tr><td colspan="3">

MATERIALS LIST
- Arches 140-lb. (300gsm) cold-press paper (full sheet stretched on basswood board)
- Soft-lead pencil
- Sketch paper
- Graphite paper (drafter's transfer paper)
- Masking fluid

</td><td colspan="2">

- Rubber cement pickup
- Small triangular-bladed palette knife
- No. 6 round synthetic brush
- Kolinsky sable brushes: 1-inch (25mm) flat, no. 6 and no. 9 rounds
- 10 pouring cups
- Winsor & Newton watercolors:
 ~ Cadmium Yellow

</td><td>

~ Cobalt Blue
~ Hooker's Green
~ Permanent Rose
~ Winsor Blue
- Daniel Smith watercolors:
 ~ Carbazole Violet
 ~ Cobalt Teal Blue
 ~ Phthalo Blue
 ~ Quinacridone Burnt Orange
 ~ Quinacridone Gold

</td></tr>
</table>

[STEP 1] Begin Sketch

Begin the painting with a sketch to design the composition. It helps to do this on a piece of drawing paper, not on your watercolor paper: You may have to erase and move lines in order to create a good design for your painting. Erasures depress the surface fibers on watercolor paper, which diminishes the watercolor transparency. Notice how I drew the seagulls on separate papers so they could be moved around. This is easier than drawing and erasing each bird if I want it in a slightly different position.

[STEP 2] Transfer Design, Save the Whites and Prepare Pouring Cups

Transfer the design to your stretched watercolor paper. Lay a piece of graphite paper (dark side down) on the watercolor paper, and place the sketch on top of the graphite paper. Tape the edges to hold everything in place while you trace the design. Use medium pressure on a soft-lead pencil to do the tracing. Too light a pressure will not transfer the design; too heavy a pressure will leave deep grooves.

Now save any white spaces you will need. Sometimes you can do this by simply not allowing paint to flow near an area you want to remain white. If you are glazing and using a lot of water, or if you have small areas or lines to be saved, it is best to mask them out with masking fluid. To do this, soap up a no. 6 round synthetic brush and dip it into a small amount of masking fluid. Paint the mask over the drawings of the birds. Use a palette knife dipped into masking fluid to drag the fine lines that appear as foam on the waves. Rinse your brush and knife clear of any remaining masking fluid.

Next, mix four separate cups of paint. Use Cadmium Yellow in one cup. Add enough water to form a light creamy consistency; it should be a strong color but easily pourable. Use the second cup for a mixture of Permanent Rose. The third cup should hold Quinacridone Gold, and the last cup should have Quinacridone Burnt Orange in it.

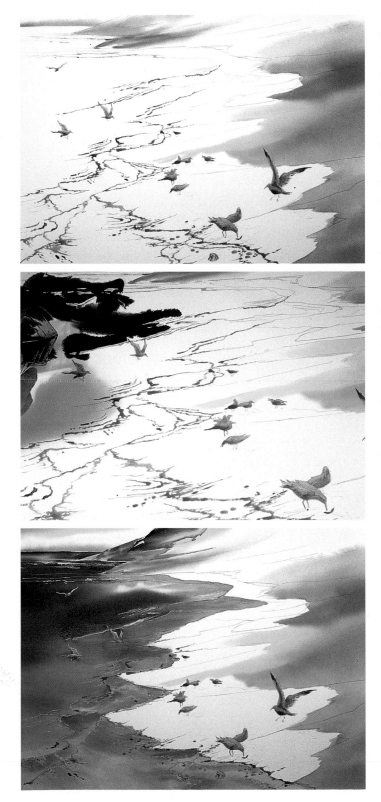

[STEP 3] Pour the First Wash

With a 1-inch (25mm) flat sable brush, wet the sandy hill area at the top of the painting with clear water. This part of the design should be completely dampened. It should not have standing water on it, so drain off any pooled water. I like to tip my board and run off the water instead of brushing it off. Every brushstroke on the paper flattens the surface fibers.

While the paper is wet, pour a small amount of Cadmium Yellow and Quinacridone Burnt Orange into the wet area at the top of the painting where the sand meets the water's edge. Tilt the support board to carry the color in streaks up the hillside toward the top right corner and allow it to drain off the paper. Do not cover all of the area with paint; remember to leave some white spaces. Allow this portion to dry.

Wet the beach area on the right side of the paper. Drain off the excess water. Working your way down the beach side of the painting, alternate poured glazes of each of these four colors: Cadmium Yellow, Permanent Rose, Quinacridone Gold and Quinacridone Burnt Orange. Pour small amounts of one color onto the wet paper, tip and tilt the board, then pour on the next color and tip again. You will be able to control the run of the colors if you do not pour on too large an amount. The colors will run and blend together evenly because they are analogous. They will cover only the parts of the paper that are wet. This is a wet in wet process. Work quickly so that the paper does not begin to dry.

[STEP 4] Continue Glazing

Into separate cups, mix pools of each of the remaining colors: Winsor Blue, Cobalt Blue, Hooker's Green, Phthalo Blue, Carbazole Violet and Cobalt Teal Blue. With a 1-inch (25mm) flat sable brush, wet the entire ocean area, carefully edging the wave that runs up to the sand. Leave the damp sand areas dry for now. Pour the darkest and coolest colors onto the far ocean near the horizon. Begin with Winsor Blue, then Phthalo Blue, then Carbazole Violet. Tilt the board to encourage a bit of color merging. Use a no. 9 round sable brush to bring the colors into the waves running up onto the damp sand.

[STEP 5] Move From Cool to Warm

Continue to pour on the other colors and allow some white spaces to remain. As you approach the foreground, pour Cobalt Blue, Cobalt Teal Blue, then Hooker's Green and finally Cadmium Yellow. The ocean is coolest at the horizon and warms as it gets closer to the foreground. The color temperatures suggest depth of field.

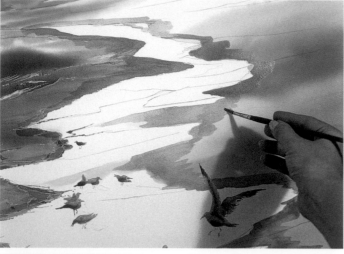

[STEP 6] Prepare Edges for a Brush-Painted Area

Use a soaped no. 6 round synthetic brush to apply masking fluid to the areas surrounding the damp sand portion of the painting. Mask 1 inch (3cm) beyond the edges of both the right and left sides of this area.

[STEP 7] Paint Damp Sand

With a 1-inch (25mm) flat sable brush, drag colors straight down the damp sand. Pull each stroke of color down the entire prepared area. The mask you put on will save the previously painted ocean and dry sand. Use Permanent Rose at the top left, then continue with Quinacridone Burnt Orange and Cobalt Blue. As you approach the foreground, dip your brush into the cups of cooler, deeper shades. Paint Carbazole Violet into the sand under the largest birds. It will create a value contrast with their white feathers. Notice that the ocean colors are cool in the distance and warm in the foreground. The damp sand is just the opposite: warm in the distance and cooler in the foreground.

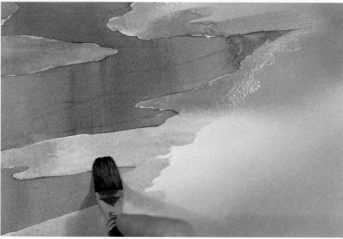

[STEP 8] Remove Masking Fluid

When you are finished painting and everything is completely dry, remove the masking fluid. Use a rubber cement pickup. This small square eraser easily picks up the mask with minimal damage to the paper.

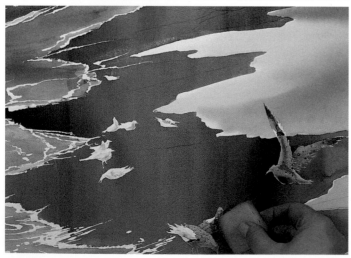

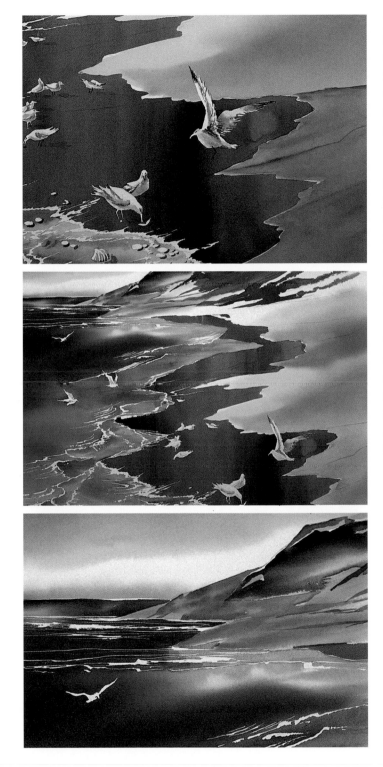

[STEP 9] Add Finishing Touches

With a no. 6 round sable brush, add a few finishing touches. Be selective where you put tiny detail, because it can become distracting. Use the most detail work at the center of interest. The birds in the foreground need detail, but the other birds are too far away to have detail. Add shadows under the birds that are standing on damp sand and under the shells in the near water.

[STEP 10] Evaluate the Painting

Step back and give the painting a critical evaluation. At this point, I think the distant hillside is weak, the hard-edged violet streaks on the hill are distracting and the sky is too pale. Additional glazes will help in each problem area. The hills need a warm glaze to contrast with the cool water. This will also subdue the harshness of those hard edges. If the hills are warm in color, it is a result of reflected light from a warm, golden sun. So glazes of orange and gold will intensify the atmosphere.

[STEP 11] Add Final Glazing

To improve the sky, lightly brush that area only with clear water. Pour on a streak of Quinacridone Gold. Leave a white streak in the sky to allow for a light atmosphere effect. When the gold is completely dry, re-wet the sky, and starting on the top left corner, pour a bit of Quinacridone Burnt Orange over the Quinacridone Gold. Tilt your board to the right and encourage the color to run toward the hillside, then back toward the left to drain off any excess paint and water. Let dry.

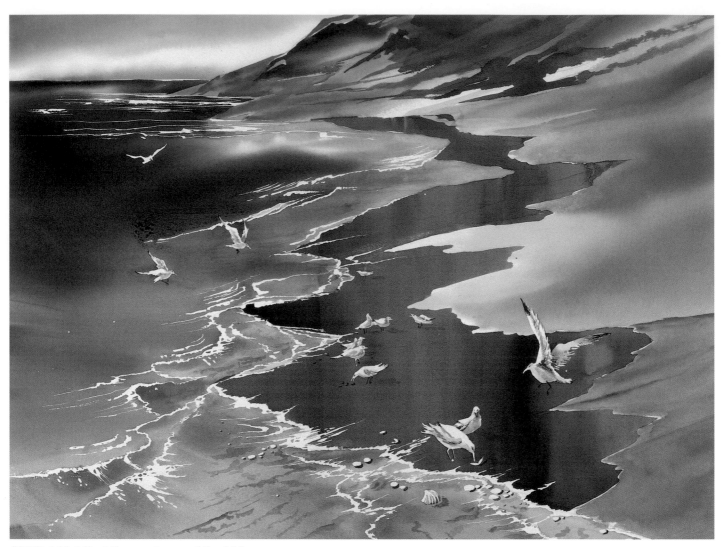

[STEP 12] Adjust Temperature and Hard Edges
With an Overglaze

The distant hills and far beach area on the right side of the painting need
to be warmer, and the hard edges should have less impact. Wet the distant
hillside area down to the middle of the paper. Pour Permanent Rose onto
the hillside from the top right corner of the painting. Tilt the board so the
color sweeps down into the beach.

 Notice that the left side of this painting is cool and the temperature
warms as you move to the right side. Within the ocean and the damp sand
areas, color temperature shifts from cool to warm and from warm to cool.
A painting is made more exciting by changes in color temperature.

BEACHCOMBERS
20" x 28" (51cm x 71cm)
Collection of the artist

Positive and Negative Images

Creative artists learn to explore shape. We develop a thought process that involves seeing things around us in many different ways. Shape is an important element in paintings. The placement of shapes and how we express them are more important than the subject of a painting. Shapes develop patterns and balance. If your art is out of balance (too many shapes of the same size, too many shapes in a jumble of sizes, no movement within the shapes, no direction to the placement of the shapes), your subject will not matter. Your art will not attract and hold the attention of viewers.

Paul Cézanne believed that the arrangement of shapes is the key to perfect balance, even if that means a distortion of nature. He worked to achieve a beautiful, harmonious pattern of shapes in which one form seemed to play on the next, strengthening the feeling of natural harmony. E.H. Gombrich writes in *The Story of Art*, "[We] speak of art whenever anything is done so superlatively well that we all but forget to ask what the work is supposed to be, for the sheer admiration of the way it is done."

One way to work with shape is to develop a pattern of both positive and negative images; shapes can be either positive or negative. Positive shapes are those of actual objects, and negative shapes are those around or between the objects. One is just as important as the other. Used together, the contrast of these impressions creates a dynamic interplay of patterns. It also helps to describe depth, since positive images appear nearer to us and negative ones recede.

Positive painting is comfortable and familiar. We paint an object as we see it in its solid form. When we enter the world of negative images, we expand the realm of realism. Use negative shapes to echo positive ones, to describe an object in a different way or to offer repetitive images of a particular shape from two different perspectives.

Negative painting expresses a movement from the surface of a painting to progressively deeper spatial planes. The transition from positive to negative to positive creates a charge of energy. This set of contrasts will dramatize the interpretation of your subject and add depth to your painting.

POSITIVE IMAGE OF A FLOWER

NEGATIVE IMAGE OF A FLOWER

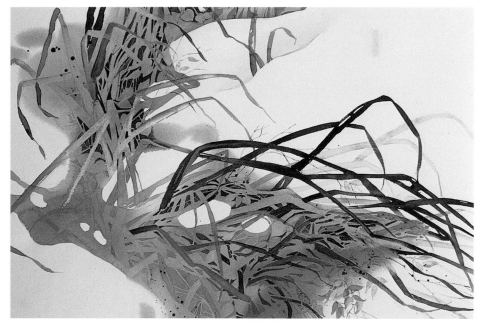

The interplay of positive and negative shapes creates intriguing patterns in a subject as ordinary as tufts of dried grasses.

SPRING'S PROMISE
20½" x 28½" (52cm x 72cm)
Collection of the artist

FLORAL PALETTE

In this demonstration painting, we will develop positive images of flowers, leaves and stems. We will echo those shapes with negatively painted images of the same objects. Building upon the colors glazed on in the first wash, we will develop a harmonized, analogous color scheme with shapes that appear to move forward in the composition and shapes that appear to recede deep into the arrangement. A strong value contrast will exaggerate the spatial movement. The trigger spray bottle technique (see page 67) will add the contrast of a loose, abstract flow to the tighter rendering of the floral shapes. The pump sprayer technique (see page 56) will suggest a leafy pattern to enhance selected edges.

MATERIALS LIST
- Arches 140-lb. (300gsm) cold-press paper (half sheet, stretched)
- Trigger spray bottle
- Pump spray bottle
- Sketch paper
- Graphite paper
- Soft-lead pencil
- Kolinsky sable brushes: no. 6 and no. 9 rounds
- 5 pouring cups
- Damp sponge
- Daniel Smith watercolor:
 ~ *Permanent Red*
- Winsor & Newton watercolors:
 ~ *Antwerp Blue*
 ~ *Aureolin*
 ~ *Cadmium Yellow*
 ~ *Cobalt Blue*
 ~ *New Gamboge*
 ~ *Rose Madder Genuine*
 ~ *Permanent Sap Green*
 ~ *Scarlet Lake*

[STEP 1] Develop Sketch and Prepare Pouring Cups

Look through your reference file for floral shapes. It is not important to replicate exact flowers of any specific nature. To get started, develop a rough sketch of interesting floral shapes. A diagonal sweep and movement toward the focal area (the cluster of flowers with a large rose in its midst) dramatizes the composition.

Develop your sketch on a separate sheet of drawing paper. It is helpful to work out a color scheme at this stage. I often make notes on the sketch as reminders, such as where I want to retain white spaces or where I will add a sweep of color.

Transfer the basic sketch to your prepared watercolor paper by tracing over a graphite sheet.

Next, mix five separate cups of paint. Each cup should contain a single color as follows: Cobalt Blue, Rose Madder Genuine, Permanent Sap Green, Antwerp Blue and New Gamboge.

[STEP 2] Pour the First Wash

With a pump sprayer, apply clean water to the paper surface. Make sure it is completely wet and does not have dry spots that catch when you run off the excess water. Gently pour Cobalt Blue onto the top left corner and pour a small amount of the same color on the right middle side. Tilt the board to spread and vignette the soft edges of the glaze. Pour approximately the same amounts of Rose Madder Genuine on the top right corner and on the left side. Let these washes dry.

[STEP 3] Add Another Layer of First-Wash Colors

Re-wet the entire surface using your pump spray bottle, then drain off the excess water. Now, pour on Permanent Sap Green and small areas of New Gamboge and Antwerp Blue. These glazes all radiate out from the upper center of the paper where the focal area will be developed. The white areas are important to preserve, because you will be using a lot of bright color for the flowers and painting over a glaze would dull the intensity of the hues. Drain a wash of Cobalt Blue down the center. Let dry.

[STEP 4] Separate the Objects

On your palette, mix a variety of greens ranging from yellow-green to blue-green. Use Cadmium Yellow or Aureolin with Antwerp Blue for strong shades of green. Starting at the top center of the paper, begin to develop negative branches. Remember, you are painting around the branches, not the branches themselves. Hard edges describe and soft edges do not, so soften any edge that does not delineate a branch. Use your no. 6 round sable brush and keep a container of clean water nearby for those soft edges. It is helpful to have a damp sponge at hand to tap your brush onto after each rinse. The sponge will draw just enough water out of your brush so that you do not flood the painting.

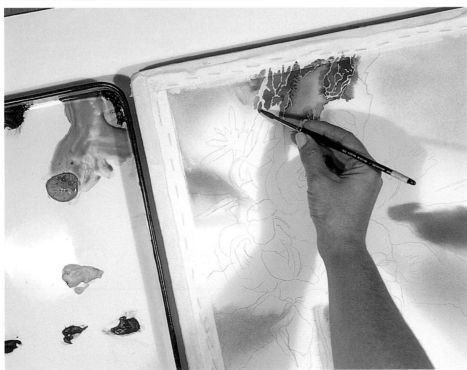

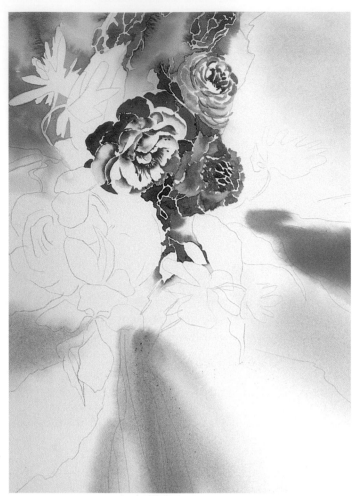

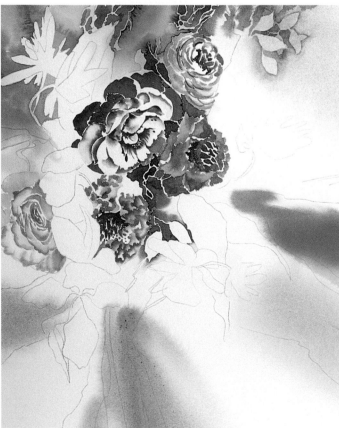

[STEP 5] Create Positive and Negative Images

Continuing down into the focal area, create the large red rose by using a series of hard and soft edges. Begin by painting the bottom petals of the flower in Permanent Red. As you move closer to the center of the flower, paint each petal edge with a single stroke of color. Work on one petal at a time. While the paint is still wet, use a no. 6 round sable brush dampened with clear water to soften the inside edge of each stroke. Use Permanent Red for this flower. Use Rose Madder Genuine for the top right flower and Cadmium Yellow, Scarlet Lake and Permanent Red for the lower right flower. The white spaces are important even within the flower shapes. They offer light that contrasts with the intense color of the positive shapes. They also allow detail to be added and suggest illumination on the flowers.

Create negatively painted flowers on the upper left. Using the same Cobalt Blue that was poured in the first wash, paint around the flower forms. With a no. 6 round sable brush, paint a stroke of blue around each petal. Work in small sections, one or two petals at a time, so that the paint does not dry and leave a hard edge where it is not wanted. As you paint around each petal, you will leave a stroke that has two hard edges. The edge on the inside of the stroke will stay a hard edge. It will describe the petal. The outside edge of the stroke needs to be softened so that it does not describe anything. It should vignette into the surroundings. Dip a no. 9 round sable brush into clean water, place the brush 1 inch (3cm) away from the edge to be softened and bring the brush into that side of the stroke. Continue until the entire outside edge of the stroke is softened. Rinse your brush often so you don't drag color into the vignetted area.

[STEP 6] Paint Negative Shapes With a Shade of the First-Wash Color

Use the same negative painting process on the leaves at the upper right. Since the initial glaze in that area was Rose Madder Genuine, paint around the forms with that color. Soften all outside edges using clear water and a no. 6 round sable brush.

Paint the remaining two flowers using the positive painting process. Make a hard edge and a soft edge for each petal. Modifying the shapes within the petals will make a more interesting impression.

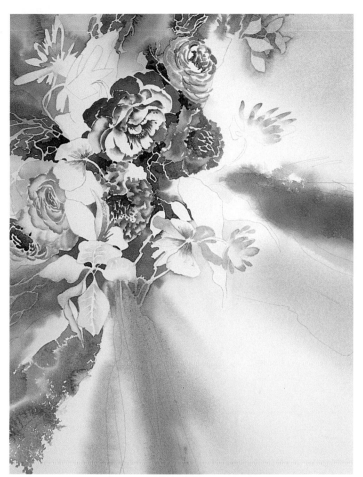

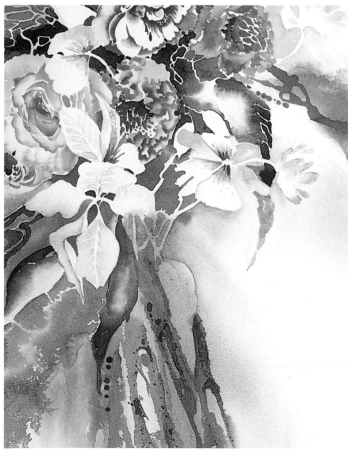

[STEP 7] Utilize Special Techniques

Some special techniques will add a bit of zip to this painting. Create a leafy pattern on the lower left side by spraying an area of water droplets with the pump sprayer. Drop Antwerp Blue onto the water pattern and tilt the board to run the color. Blend some areas within this section using a dampened no. 9 round sable brush. Repeat this technique on the top side of the green area that flows off to the right. If you use a special technique in one area of a painting, it is wise to repeat it at least once more in another area. It will not pop out at you as much if it is used more than once. Remember, these techniques are meant to add interest, not dominate.

Continue to develop negative images in the lower middle area. Using a no. 6 round sable brush, paint around the shapes with a darker shade of the first-wash colors of Cobalt Blue, Rose Madder Genuine and Permanent Sap Green. Work on one or two petals at a time so that each stroke of color stays wet long enough for you to soften the outside edge of the stroke. Use a no. 9 round sable brush dampened in clear water for this vignetted edge. If the area is small or other objects are close by, use a no. 6 round sable brush for the vignetting.

[STEP 8] Add Finishing Touches

Using a trigger sprayer, run a few splashes of water down the center, then drop Permanent Sap Green from a fully loaded brush onto them and tilt the board to run the color. Where the sprayed water lines run over the blue, drop on Cobalt Blue. (See page 67 for details on using a trigger sprayer.)

Add a few linear strokes to the green area at the right side. These may appear as branches or possibly shadows, but they add a good contrast to the soft even washes behind them. Drag a no. 6 round sable brush dipped in water along some branchlike lines. When you are satisfied with the water stroke pattern, drop onto them (from a brush dripping with paint) a dark value of Permanent Sap Green (mixed to its most intense color—a water-to-pigment ratio the consistency of heavy cream). Tip your paper to encourage the color to run along the water stroke lines.

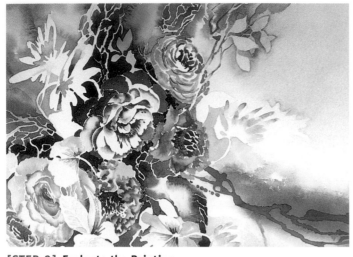

[STEP 9] Evaluate the Painting

A stronger value pattern will enliven the composition. Mix a pool of ten parts Antwerp Blue, four parts Permanent Sap Green and three parts Rose Madder Genuine. Go back into the focal area and add this darker value of blue-green to the negatively painted background.

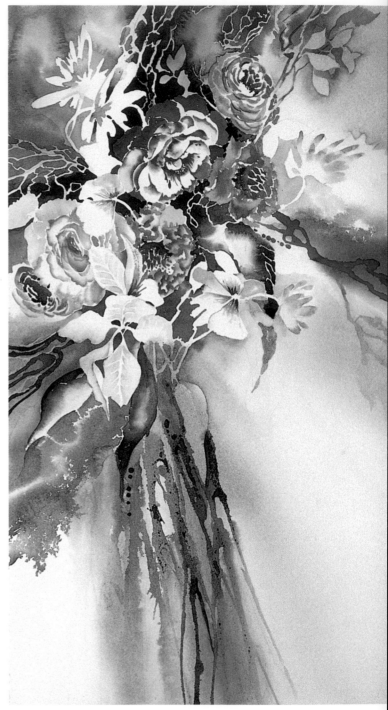

FLORAL PALETTE
21" x 14" (53cm x 36cm)
Collection of the artist

Hard and Soft Edges

Maximize the natural qualities of water-color by taking advantage of a variety of edge effects. Wet-in-wet painting sets the stage for soft, flowing edges. These blurred shapes are an inherent part of the nature of watercolor. Emphasizing the soft, sometimes referred to as "lost," edges will actually make a contrasting hard edge stand out more. You can lead the eye of your viewer by selective placement of soft (lost) and hard (found) edges.

The mingling of edge variety creates an intriguing journey for a viewer. If, for example, the focal area is described in hard edges while the rest of the piece has soft edges, you can stir movement throughout a painting by a subtle serenade of smaller, less intense but cleverly placed hard-edged shapes leading to the area of interest. The trick is to develop a lively approach to the center of interest without concocting a busy or jumpy jumble of sharp shapes. You will have to judge the balance between hard and soft edges by evaluating flow and movement. Hard edges attract attention and suddenly stop the eye. Soft edges are rest areas where the eye can linger.

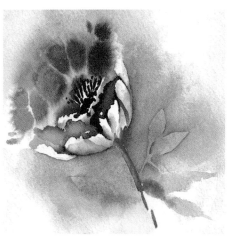

Hard edges attract attention. Soft edges are restful.

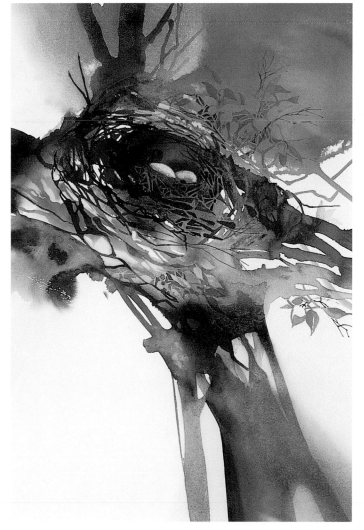

Enhance the intrigue of your paintings by depicting some objects with soft edges only. Every part of an image does not need to be completed with a hard edge.

HOMEWARD BOUND
28" x 21" (71cm x 53cm)
Collection of Kim Skrzypczak

MORNING SONG

This demonstration emphasizes the contrast of hard and soft edges. In the first wash of colors, we will create a base of soft-edged shapes. We will weave a pattern of soft-edged shapes that become more hard edged as they build to a crescendo at the center of interest. Positive and negative images will suggest depth in the scene. The pump spray bottle technique (see page 56) will hint at obscure foliage, and we will use a paint-lifting technique (see page 64) to lighten specific areas in the painting.

[STEP 1] Develop Sketch and Prepare Pouring Cups

Prepare your sketch on a separate piece of paper. Once you have decided on a subject, review the guidelines for developing an image into a good design. In this demonstration, the birds will become the focus. Sketch them on separate pieces of paper so that you can move them around to the best spot. The diagonal shaft through the sketch will add movement and drama to this composition. When you are satisfied with the composition, place graphite paper (dark side down) on your prestretched watercolor paper and lay the sketch on top of it. Trace the sketch onto the watercolor paper.

Mix Cobalt Blue paint in a cup; mix Hooker's Green in a separate cup. In a third cup, mix Permanent Rose with Quinacridone Magenta. Mix in the fourth cup Winsor Blue and Phthalo Blue. In the last cup, mix Permanent Rose, Winsor Blue and Carbazole Violet.

[STEP 2] Pour the First Wash

Wet the entire surface of the paper with the pump spray bottle. Begin by pouring Cobalt Blue onto the top right corner. While the blue is still very wet, pour Hooker's Green onto the top center portion of the paper. Tilt the board slightly to run these two colors together and soften the edges. Allow the paper to dry.

MATERIALS LIST

- Arches 140-lb. (300gsm) cold-press paper (half sheet, stretched)
- Sketch paper
- Graphite paper
- Soft-lead pencil
- Oil painting bristle brush
- Masking tape
- 5 pouring cups
- Pump spray bottle
- Paper towels
- Kolinsky sable brushes: 1-inch (25mm) flat; no. 5, no. 6 and no. 9 rounds
- Winsor & Newton watercolors:
 ~ Cobalt Blue
 ~ Hooker's Green
 ~ Permanent Rose
 ~ Quinacridone Magenta
 ~ Winsor Blue
- Daniel Smith watercolors:
 ~ Carbazole Violet
 ~ Phthalo Blue

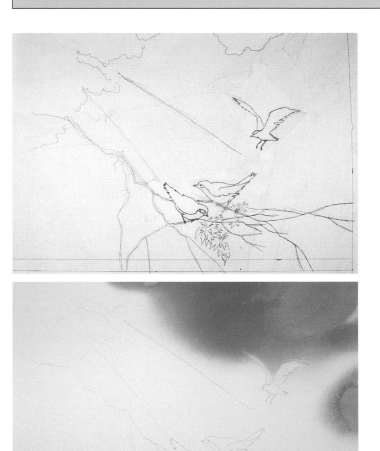

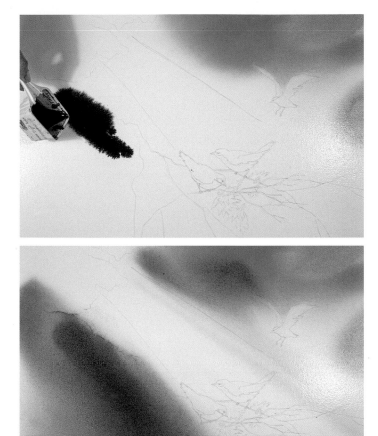

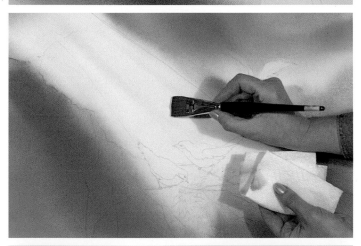

[STEP 3] Slide on Another Layer of First-Wash Glazes

Re-wet the entire sheet of paper with the pump sprayer. Pour the Winsor Blue/Permanent Rose/Carbazole Violet mixture in a diagonal shaft through the center portion of the composition. Slide the paint onto the wet surface rather than dumping it on. Pigment that is dropped or dumped onto the paper can dig into the surface fibers and cause a circular imprint that will destroy the beauty of a smooth glaze. Dry this first glaze.

[STEP 4] Continue Glazing With Analogous Colors

Continue glazing with the Winsor Blue/Phthalo Blue mixture poured on at the left center. Run the glaze down and along the same angle as the light shaft. Glaze Hooker's Green onto the lower-left corner. Notice that the colors are poured on in analogous order to avoid having them become muddy. Dry these glazes.

[STEP 5] Dramatize the Diagonal With a Shaft of Light

With the pump sprayer, wet the diagonal section of the composition. Drain off any standing water. Using a 1-inch (25mm) flat sable brush, drag streaks of Cobalt Blue down the diagonal. Keep these streaks soft edged by dampening your brush with clear water and pulling the brush down between the blue streaks. Wipe the brush after each stroke so that you do not spread the color between the blue strokes. Repeat the process until you have subtle, soft shafts of color. Let the paper dry.

[STEP 6] Separate the Objects

Spray the top left corner with a few pumps of your spray bottle. When the water forms droplets that are just beginning to merge together, touch a no. 9 round sable brush loaded with Cobalt Blue onto the top of a water droplet. Tilt the board to encourage the paint to spread. (See page 56 for details on spraying technique.)

DETAIL OF
FOLIAGE

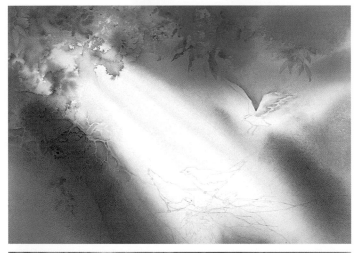

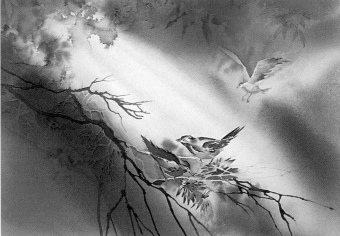

[STEP 7] Indicate Foliage

Continue spraying water and touching in paint across the top and down the left side of the painting. Remember to use the first wash of glazes as your guide to colors. If the spray pattern is on a blue wash, touch blue onto the water droplets; if it is green, touch in green. Add the suggestion of flowers at the upper left by touching into the spray pattern a brush loaded with the Quinacridone Magenta/Permanent Rose mixture.

Develop muted images of foliage in this area using a no. 6 round sable brush dipped into clean water to soften some edges and blend together some of the spray pattern. Just hinting at images of leaves, branches and flowers is best in this section since it is far away from the center of interest. Suggest some of these subtle forms in positive and negative painting, using the first wash as a color guide.

[STEP 8] Develop the Center of Interest

Wet the area around the birds, and pour on a small amount of the Quinacridone Magenta/Permanent Rose mixture to form soft-edged images of flowers. When this has dried completely, paint the birds with a variety of hard- and soft-edged strokes with a no. 6 round sable brush. Use the violet mixture of Winsor Blue, Permanent Rose and Carbazole Violet as well as the Cobalt Blue and the Winsor Blue/Phthalo Blue mixture. Begin by painting the heads and bodies with Cobalt Blue. Use your no. 6 round sable brush, and remember to leave some white spaces within the body. Also, create some hard edges and soften other edges. This will help contour the shapes. With the same brush, continue to paint the birds' undersides with the violet mixture. Add feathery details with the Winsor Blue/Phthalo Blue blend. Swipe tiny strokes of color out from the tail and wings. Finally, paint in the eyes, beaks and feet with the violet mix.

Paint the detailed and hard-edged flowers near the birds. With your no. 5 round sable brush, paint the tip of each flower petal. Use a no. 6 round sable dipped in clear water to soften each petal as it gets nearer to the core of the flower.

Paint thin lines of clear water with a no. 9 round sable brush to form branches. When you have an interesting tangle of branches, dip your no. 9 round sable into the violet mixture of Winsor Blue, Permanent Rose and Carbazole Violet and touch the water lines. Tilt the board to run the dark color down to the twigs. These dark, hard edges immediately draw attention. The hard edges advance toward the viewer, and the soft edges recede into space.

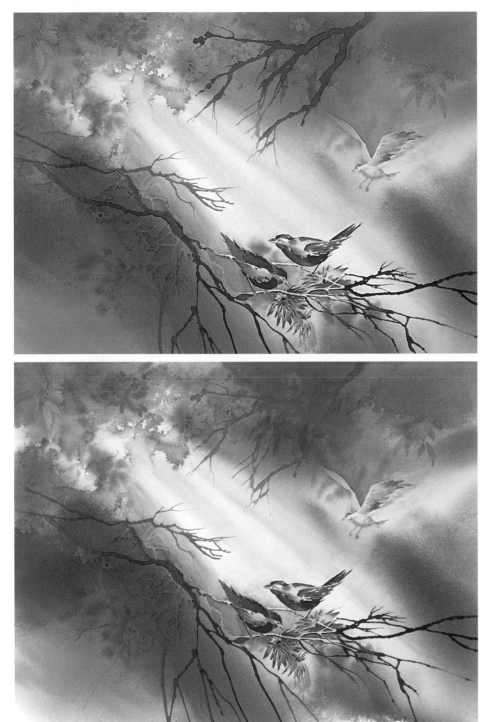

MORNING SONG
16" x 22" (41cm x 56cm)
Collection of the artist

[STEP 9] Add Finishing Touches

The painting seems somehow out of sync. The hard edges jump out as they should, but it looks too obvious. Temper the effect by adding another area of branches coming into the painting from the upper right. This will create an opposing diagonal element to the violet branches that grow from the left side down toward the bottom right. Repeat the same process you used for the first set of branches, but this time touch a brush loaded with Hooker's Green into the water lines since the underlying first-wash glaze in this area is green.

[STEP 10] Evaluate the Painting

Step away from your painting. Now is the time to adjust the value, shapes, lines and textures and to enhance the impact at the center of interest. I am concerned that those green branches are now too prominent. I like their design, but they are too dark. Lighten them by first wetting them with a no. 6 round sable brush dipped in clean water and then gently patting them with a clean paper towel to lift off some of the paint. Retrace the branch lines with the water, allow it to sit for a minute, then spray it with the pump sprayer. If it does not lighten sufficiently, lightly scrub the branches with a wet, small oil painting bristle brush and spray again.

The soft-edged pink flowers between the birds are distracting. They dried a bit too dark. It would be better to have a stronger value contrast between the birds and the atmosphere around them. Lift the paint in this area by first taping over the birds with masking tape. Press the edges of the tape down securely so that no water seeps under the edges. Wet the soft pink flowers with clear water and let it sit for a minute. Soak up the water with a clean paper towel. Lightly scrub the area with a no. 6 round sable brush and clean water. If this does not remove enough color, carefully scrub with a wet, small oil painting bristle brush. Let the paper dry, and remove the masking tape. Now the focus is on the hard edges at the center of interest.

Light and Dark Values

Artists are like storytellers, and the best storytellers know how to communicate effectively. This means weaving a pattern of intrigue and then zeroing in on the plot or the focus of the work. Contrasting values create a dramatic image and an interesting pattern that will quickly attract the eye.

Every color has a value range that runs from a very pale light to its richest dark. In its purest form, a pigment is mixed with just enough water to provide spreadability. Determine the ratio of water to pigment by testing the mixture to see that it is deep and rich in color yet still transparent. This is the darkest value of that particular color.

Middle values have a more equal ratio of water to pigment. Again, this varies with the different pigments. Some colors, like Winsor Red, need a bit more water added because of the strength of the pigment. Others, like Lemon Yellow (Nickel Titanate) may need less water to bring the value to a middle range. If a lot of water is added to just a little pigment, the result is a tint or light value.

Plan the arrangement of rich darks, connecting middle tones and contrasting light areas. A dark value pattern should dance around the painting in an intriguing array of shapes. A value pattern means that the dark passages are mostly connected and they flow in a balanced and interesting design. If they are scattered around, the result will be a chaotic dappling of darks that will actually distract and confuse.

Use the maximum contrast of values at the center of interest, the darkest darks next to the lightest lights. Begin to incorporate the middle tones as you move away from the focal point. There should be a gradual progression of less and less contrast as you get farther from the focus area.

We can create the effect of illumination by employing dark-to-light contrasts. Light areas generally project forward, and dark values recede—just as warm colors advance while cool colors recede and positive images advance and negative shapes recede. Now we have three contrasting treatments to indicate depth of field. These are ways two-dimensional art projects spatial depth. In the High Renaissance, the Old Masters expertly employed the theories of light and dark contrast throughout their compositions. *Chiaroscuro* is the term given to a design concept used to create a sense of intense illumination and movement.

Don't be afraid to use strong and aggressive values. Reorganize your composition, if necessary, to take advantage of light and dark interplay. An otherwise ordinary painting can take on a dramatic impact if exaggerated value contrast is used.

SKETCH FOR *THE FARMHOUSE*
I took advantage of bright sunlight on this white house. These on-location sketches reflect various value judgments and composition possibilities for the final painting.

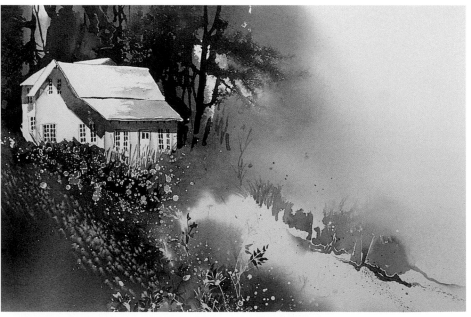

A very strong value contrast dramatizes the light in this painting. Hard edges on the farmhouse focus attention. Soft edges are restful.

THE FARMHOUSE
13½" x 20½" (34cm x 52cm)
Collection of Dr. and Mrs. Robert Balderson

DONAN BRIDGE

This demonstration for light and dark values includes predetermined areas of white space, a limited palette of glazed colors and some special techniques. White spaces can be saved by three methods: (1) not allowing the wash colors to flow over a specific area, (2) preserving with masking fluid and, (3) in very specific small areas, preserving with masking tape. We will aggressively apply many layers of glazing to develop a deep value contrast. The pouring cups will be prepared with glowing color combinations that will give us intense glazes of orange, red and violet.

With a palette knife, we will draw

linear paths that cut through and break up the flat foreground spaces. The dip pen technique is perfect for the fine detail at the center of interest, and the pump spray bottle technique will create

an illusion of foliage as well as a variation in edge treatments. Maintaining the value contrast between white or light areas and dark areas is the goal.

MATERIALS LIST

- Arches 140-lb. (300gsm) cold-press paper (half sheet stretched on Homasote board)
- Palette knife
- Dip pen
- Pump spray bottle
- Paper towels
- Masking fluid
- Masking tape
- Rubber cement pickup
- Sketch paper
- Graphite paper
- Soft-lead pencil
- No. 5 or 6 synthetic brush
- Kolinsky sable brushes: 1-inch (25mm) flat and no. 6 round
- 5 pouring cups
- Bar of soap
- Winsor & Newton watercolors:
 ~ Brown Madder
 ~ Burnt Umber
 ~ Cadmium Yellow
 ~ Permanent Rose
 ~ Quinacridone Gold
 ~ Quinacridone Magenta
 ~ Scarlet Lake
- Daniel Smith watercolors:
 ~ Carbazole Violet
 ~ Permanent Red

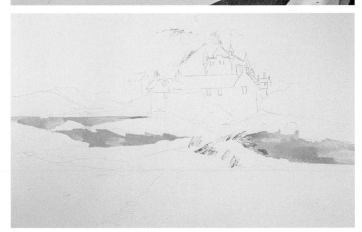

[STEP 1] Prepare Sketch

This composition, done on sketch paper, is an accumulation of several buildings from my reference file. The center of interest is placed in the upper-right section, and the surrounding landscape is designed to lead the eye toward that area. Notice the horizontal, vertical and diagonal elements in the design.

Transfer the sketch onto your prestretched watercolor paper by laying a graphite sheet down on the watercolor paper and then tracing over the sketch.

[STEP 2] Preserve White Spaces and Prepare Pouring Cups

Mask the pond areas with masking fluid. Rub an old no. 5 or 6 synthetic brush over a bar of soap. Be sure to get the soap all the way up to the ferrule. Dip the brush into a small amount of masking fluid, and paint in the pond areas. Rinse your brush and resoap it after sixty seconds of using the mask, so you will have no problems with the masking fluid sticking to your brush. Allow the masked pond areas to dry.

Mix paint in five pouring cups: (1) Cadmium Yellow; (2) Cadmium Yellow with Scarlet Lake; (3) Carbazole Violet, Permanent Rose and Quinacridone Magenta; (4) Permanent Red and Quinacridone Gold; and (5) Permanent Rose.

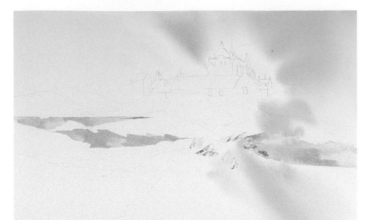

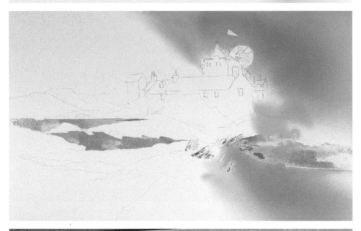

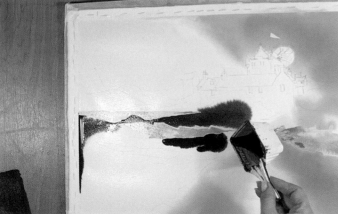

[STEP 3] Pour the First Wash

Wet the entire paper with clear water using your pump sprayer so the surface fibers are not damaged. Drain off excess water.

Pour a small amount of Cadmium Yellow from its cup onto the upper-right section of the paper. Tilt the board so that the paint runs around that area, but avoid having it run over the castle. Try to keep that area white. If color does run over an area you wish to keep white, simply spray off the paint with your pump sprayer. Do not attempt to soak up the paint and water. Instead, allow it to run off the nearest edge of the paper. Dabbing it with paper towel, for example, will grind the pigment into the paper and reduce the transparency of the glaze. Let the paper dry.

[STEP 4] Continue Glazing

Preserve the white paper for the sun and the flag by taping over the areas with masking tape. You could use masking fluid to do this, but it would leave a definite edge, and I prefer a softer, more natural edge.

Re-wet the paper using the pump sprayer and drain off the excess water. Pour the orange mixture of Cadmium Yellow and Scarlet Lake over the same area. Tilt the board to blend the color. Allow some of the paint to bleed down onto the lower-right section of the painting. Let the paper dry.

[STEP 5] Pour a Third Glaze

Re-wet the entire paper using the pump sprayer. Slide the violet mixture of Carbazole Violet, Quinacridone Magenta and Permanent Rose onto the paper starting close to the center. Tip the board so that the wash runs off to the left side and down toward the lower-left corner. Let this wash dry.

[STEP 6] Establish Movement With a Glaze

Repeat the process with the same color, running the second wash down from the upper-left corner toward the center of the paper. You are establishing movement toward the center of interest by the direction of these first-wash glazes. Let the paper dry.

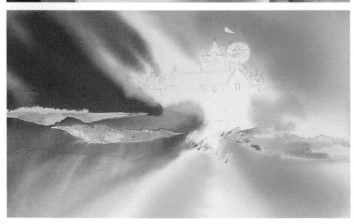

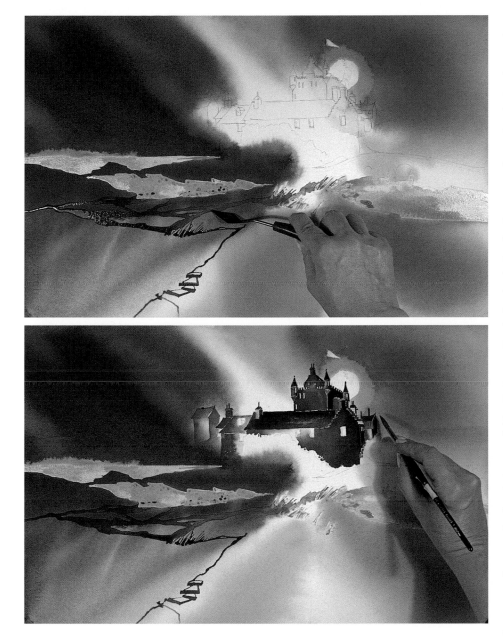

[STEP 7] Overglaze to Deepen Value

The color and the flow of the glazes are good, but at this point, the values are in the light-to-medium range. More aggressive glazes will dramatize the light vs. dark contrast. Again wet the whole paper with your sprayer. Slide a glaze of the Quinacridone Gold/Permanent Red mixture onto the upper-left sky area. Run the wash toward the center.

Slide a glaze of the Cadmium Yellow/Scarlet Lake mixture onto the upper-right sky. Run this glaze off the right side. Notice that as the glaze dried, the masking tape on the sun caused a bloom to form around the sun. I did not intend for this to happen, and after a minute of initial distress, I saw the beauty in this natural occurrence. It appears to give the sun a halo. This is another example of watercolor having a life of its own.

Using a palette knife dipped into Brown Madder, drag linear sweeps of color off to the left side to suggest hills and land forms. Now dip your knife into the violet mixture of Carbazole Violet, Quinacridone Magenta and Permanent Rose and drag a line down a path toward the bottom left. Hint at stone steps along the way to break up the line and add interest. Avoid detail in this area. It is too far from the center of interest to pull attention.

[STEP 8] Detail the Center of Interest With Dark Values

Remove the masking tape on the flag. With your no. 6 round sable brush, begin to paint in the castle. Use the darkest value of Burnt Umber, the Carbazole Violet/Quinacridone Magenta/Permanent Rose mixture and the Quinacridone Gold/Permanent Red mixture. This is the place to include fine detail. Lessen the detail as you move away from the sun.

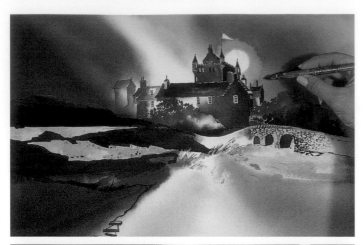

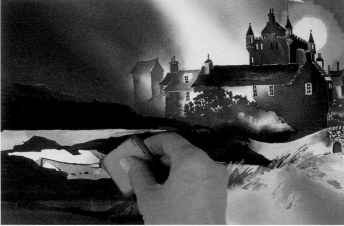

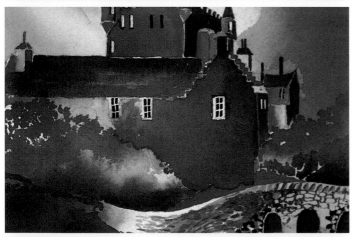

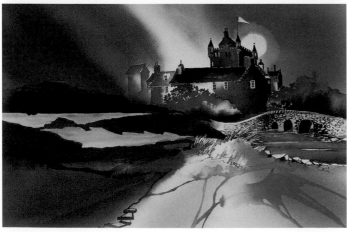

[STEP 9] Dramatize Value Contrast With Another Layer of Glazing

Another glaze of the Carbazole Violet/Quinacridone Magenta/Permanent Rose mixture on the bottom left section of the painting will deepen the value and reduce the attraction to that area. When this glaze dries, paint in the distant hills and the left middle ground with the same violet mixture. Use a 1-inch (25mm) flat sable or other soft natural-hair brush for this to minimize the brushstrokes needed. Add subtle interest to the left foreground by stroking in lines with the Quinacridone Gold/Permanent Red mixture using your no. 6 round sable brush. Use a dip pen filled with a creamy consistency of Burnt Umber to draw fine lines on the building and on the bridge. (See page 69 for details on using the dip pen.) Dry the paper.

[STEP 10] Utilize Special Techniques

Remove the masking fluid by gently rubbing across it with a rubber cement pickup. Next, form foliage around the castle. Lay paper towels above and below the foliage areas to keep them dry while you spray a pattern of water droplets from your pump sprayer to form the leafy bushes. Release a drop of the Quinacridone Gold/Permanent Red mixture from your no. 6 round sable brush onto the water droplets. (See page 56 for details on spraying.) Continue this technique to the right of the castle, releasing from a no. 6 round sable brush drops of the Quinacridone Gold/Permanent Red mixture and then the violet mixture of Carbazole Violet, Quinacridone Magenta and Permanent Rose.

[STEP 11] Add Finishing Touches

Another glaze of the Quinacridone Gold/Permanent Red mixture on the upper-right sky gives a more intense glow. Darkening the value of the bridge makes a more dramatic impression. Do this by painting the shadow areas again in a darker shade of Burnt Umber. To the pond area that extends out to the left of the castle, paint in a subtle gold wash. Use a no. 6 round sable brush with diluted Cadmium Yellow so that the water appears to reflect the sky color yet contrasts with the immediate surroundings. Notice that the left side of this painting is basically dark with a light passage (the pond), while the right side is light with dark structures (the castle and the bridge). Add a few linear strokes in the foreground to lead the eye and add an impression of land forms. Use a no. 6 round sable brush dipped in clean water to draw in the free-form strokes, then touch the water lines with the same brush dipped in the Cadmium Yellow/Scarlet Lake mixture.

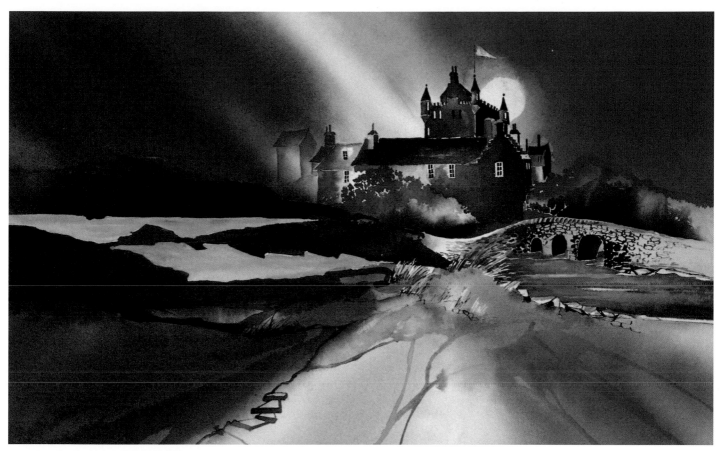

[STEP 12] Evaluate the Painting

A final glaze of Permanent Rose warms up the atmosphere. Using a pump sprayer, wet the entire paper except the area close to the castle and the bridge. Pour a mixture of Permanent Rose onto the upper-right sky and drain it away from the building. Pour the same mixture onto the middle- and lower-right sections. Save the white areas. They add relief from the intense color and emphasize the light/dark value contrast.

DONAN BRIDGE
14" x 21" (36cm x 53cm)
Collection of the artist

Illusion and Reality

In its day, the development of photography was a blow to the position of artists. Before the camera came into use, nearly every self-respecting person sat for a portrait at least once in his of her lifetime. How would we have known what life looked like in the days before photography if not for the artists who painstakingly depicted every detail? Realistic depiction was a talent in demand, and artists were busy providing a much needed and desired service. The camera changed all of that.

Perhaps those artists of the nineteenth century did not realize it at the time, but modern photography was actually a boost to their art. It encouraged people to see the charm of using an unexpected angle, and it pushed artists to explore art as an expressive medium. The rise of Impressionism began during this same time. This new group of artists found an adventurous spirit in their art. They cast aside the academic rules of art and discovered light and shape, movement and space. They reveled in the impression of a scene rather than the reality of it.

As artists, we are communicators. In order to communicate the best story, we need to intrigue the viewer. A good storyteller knows that involving the imagination of the audience makes the story more interesting. We can use that same knowledge to draw interest into our paintings.

Webster's New World Dictionary describes *illusion* as sense impressions. These are images in the mind caused by something external: a sensation, a passion, an emotion. On the other hand, reality is that which exists in nature.

Reality in your painting will attract attention. Illusion will create interest. The combination of reality and illusion offers us a way to moods and impressions and gives our art a personal vision.

When planning a new painting, I begin by identifying three things: the center of interest, the light source and the mood of the piece. Once I determine where I will concentrate the detail, I can estimate what percentage of the painting will be treated as illusion. By creating impressions or illusions in parts of the painting, the areas of detail (or reality) will attract more attention and the contrast will create interest.

Capture the essence of a scene by eliminating all but the most important detail and then offering an impression of the rest of the subject. Focus on the important shapes. How accurately you render what you see is less important than how impressively the image is communicated.

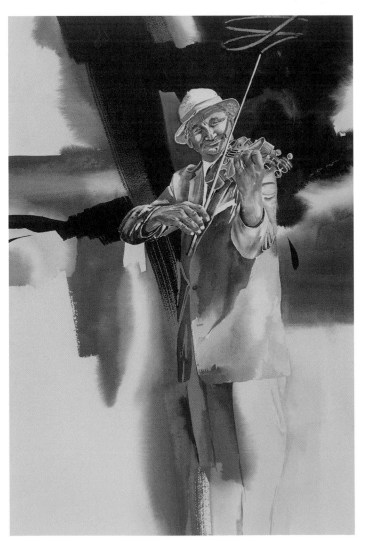

Use the illusion of activity to emphasize a mood. The figure and his surroundings are integrated into an impression of musical movement. Only the face and violin area are detailed.

MINSTREL'S GIFT
21" x 13" (53cm x 33cm)
Collection of the artist

VICTORIAN VERANDA

Suggested images are intriguing. This exercise will demonstrate how to make the most of illusion in your art. We will develop a detailed focal point and hint at the objects around it, but the rest of the painting will be left to the viewer's imagination. Spatial divisions and color transitions are important in this painting. We do not want to add so much or suggest so little that the composition becomes confusing. Building upon the first-wash colors will help ease the overall transition from reality to illusion. We will use the wet-in-wet technique and the dip pen technique for detail. Hard edges that become soft obscure edges will attract attention. That will create eye movement between areas of focus and illusion.

MATERIALS LIST		
• Arches 140-lb. (300gsm) cold-press paper (half sheet stretched) • Pump spray bottle • Dip pen • Black marker	• Sketch paper • Graphite paper • Soft-lead pencil • 4 pouring cups • Kolinsky sable brushes: 1-inch (25mm) flat, ½-inch (13mm) flat, no. 9 round	• Winsor & Newton watercolors: ~ *Permanent Rose* ~ *Permanent Sap Green* • Daniel Smith watercolors: ~ *Cobalt Teal Blue* ~ *Phthalo Turquoise*

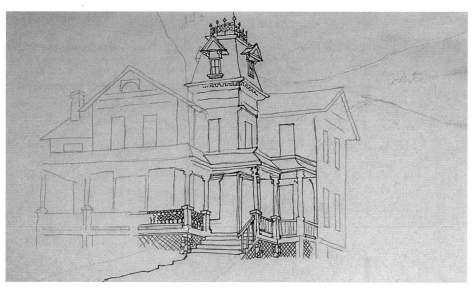

[STEP 1] Develop the Sketch and Prepare Pouring Cups

Since this demonstration emphasizes illusion vs. reality, we will develop only part of the Victorian house with realistic detail, using this as the focal point. This is a way of leading the viewer's eye toward a specific area of interest. However, every part of the painting should have interest, even the areas that are out of focus or illusionary. This is accomplished by interesting brushwork, soft-edged blooms, color changes, or maybe even simple calligraphic line work.

Indicate on your sketch paper where your focal area will be. Decide how you will draw attention to that area. Remember, the center of interest does not have to be a specific object; it can be a general area. For example, in this painting, we will emphasize a section of the veranda. Draw that area in black marker. Even though the house is situated in the middle of the paper, the focus will be only the portion of the veranda that is off to the right.

Divide the spatial planes around the house with two hard-edged lines leading out of the scene. Notice the vertical line at the top of the roof that continues right off the paper. Do the same with the sidewalk, running the line off at a diagonal toward the lower left. This hard-edged division of space will add interest, contrast the soft edges we will develop in the first wash, connect the house to the perimeters of the painting (so it will not appear to float in space), and lead the eye toward the veranda.

Transfer the finished sketch onto your watercolor paper using graphite paper. (Note the placement of the house in the finished painting on page 117). Mix each watercolor in its own cup. You will have four cups of color ready to pour.

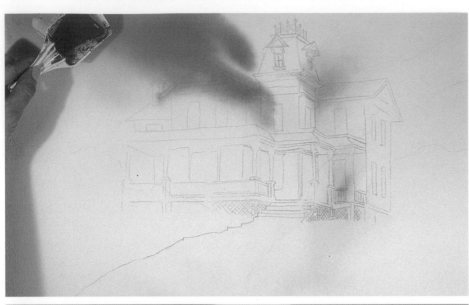

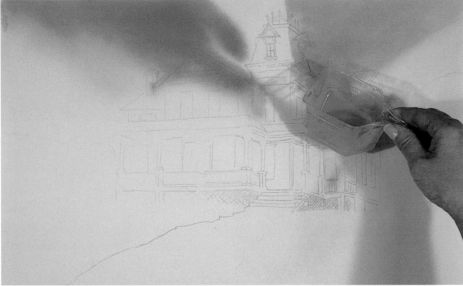

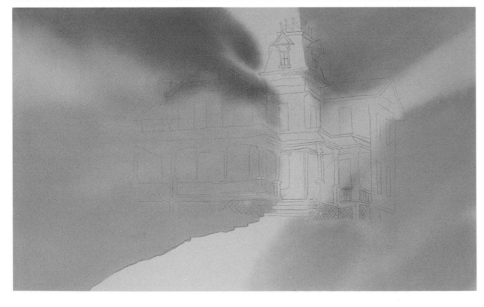

[STEP 2] Pour the First Wash

Use your pump sprayer to wet the entire prepared watercolor paper. Drain off the excess water. Pour on a bit of Permanent Rose, beginning at the upper left and draining the wash toward the center. Let this first wash dry.

[STEP 3] Pour a Second Glaze of the First Wash

Using your 1-inch (25mm) flat sable brush filled with clear water, establish a hard edge running from the top of the roof directly up and off the paper. Paint the hard edge line and then brush off the water toward the upper-right corner. Wet the paper halfway down the right side. Pour Cobalt Teal Blue onto the upper right near the house and drain it toward the corner. Take care to preserve the white areas. Tilt your paper so that the paint flows in the desired direction. You now have a wash section with one hard edge and one soft edge. Let this wash dry.

[STEP 4] Continue Glazing

Wet the lower-right section of the paper with your pump sprayer. You should dampen far beyond the area you intend to pour a wash on. A hard edge will form if the wash hits dry paper. Pour Cobalt Teal Blue on the lower right corner. Let it dry.

The area on the left side also has a wash of Cobalt Teal Blue, but this section also has one hard edge—the line along the imaginary sidewalk. Use your 1-inch (25mm) flat sable to pull clean water from the edge of the sidewalk out into the entire left side and top of the paper. Pour on Cobalt Teal Blue. The paint will spread only on those areas that are wet and will stop spreading and form a hard edge when it hits the dry paper.

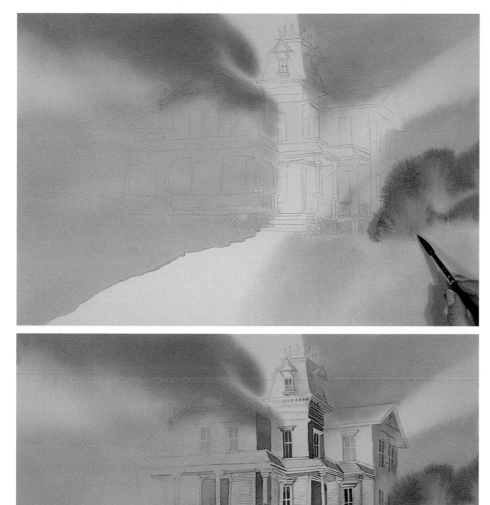

[STEP 5] Separate the Objects

Using your 1-inch (25mm) flat sable brush and clear water only, wet the right side of the paper. Sweep the brush upward and slightly in toward the center of the paper. The paper should be wet but void of pooled or standing water. Now dip your no. 9 round sable brush in the Phthalo Turquoise pouring cup and wiggle on a few strokes at the right side of the house. Tilt the paper so that the strokes of paint bleed upward. Let the paint and water do the work. If you touch the brush into this area again, you may spoil the freshness of this wet-in-wet bloom.

[STEP 6] Define the Center of Interest

In order to judge how much of the painting we want to be illusionary, we need to establish the area of interest. Fine detail will draw the eye to the area of reality. Begin by painting the shadowed sides of the house. Use your ½-inch (13mm) flat sable brush dipped into a darkened shade of the first wash colors: Permanent Rose and Cobalt Teal Blue. Where the wash is Permanent Rose, use that color mixed with some of the Phthalo Turquoise to darken it. Where the wash is Cobalt Teal Blue, mix that color with the Phthalo Turquoise to darken it.

Using a dip pen filled with Phthalo Turquoise, start to add detail to the veranda. Deep values will help attract attention to this part of the house. (See page 69 for details on using a dip pen.)

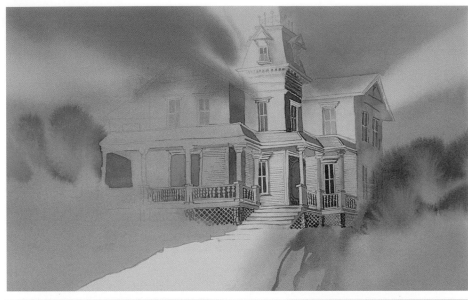

[STEP 7] Extend Areas of Illusion

Moving to the left side, repeat the wet-in-wet process you used to create the illusion of bushes on the right using a no. 9 round sable and Phthalo Turquoise. Paint with Phthalo Turquoise the space at the corner of the veranda that is open to the background.

To add interest to the foreground, release from a no. 9 round sable a puddle of clean water onto the area below the veranda on the right side, using a 1-inch (25mm) flat sable brush to create a real puddle. Tip the paper, and allow the water to drip down and off the paper. Pour Permanent Rose into this water pattern and let it drain off. This will help bring the rose color through the painting. It seemed a bit isolated at the top but now carries the eye along a more interesting path. It does not need to be defined. It gives an illusion, adds interest and forms an eye path.

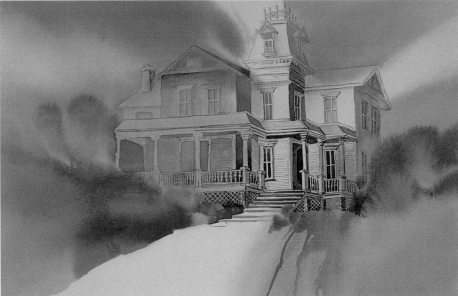

[STEP 8] Evaluate the Painting

The painting needs something. We have developed a good contrast between illusion and reality (detail); now let's take a bold step and introduce a new color to the palette. With a 1-inch (25mm) flat sable brush, paint clear water onto the left side of the paper, taking care to follow along the hard-edged sidewalk line. Pull the brush up and away from the hard edge.

Pour Permanent Sap Green onto this wet area. Tip the paper, and run the paint along the hard edge and out toward the left side. Repeat the process on the right side of the walkway and off to the right side.

The movement in this painting is flowing to the part of the porch that is in focus. The rest of the composition is colorful and suggestive but not attention grabbing. Detail attracts the eye, while illusion creates interest.

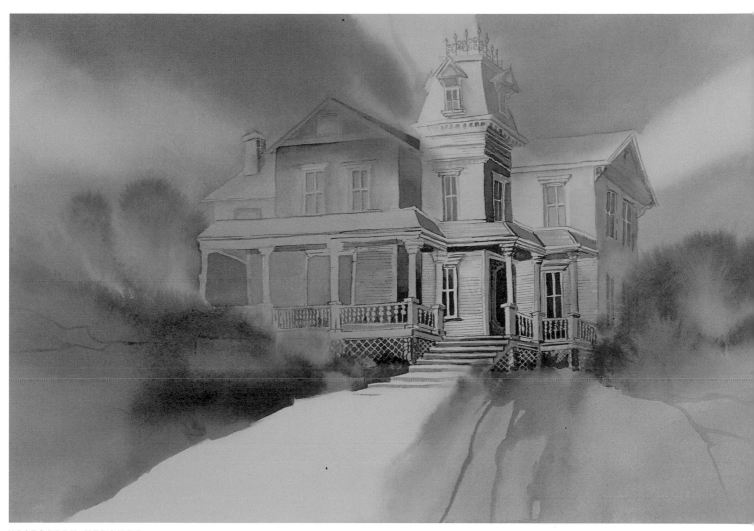

VICTORIAN VERANDA
13½" x 20" (34cm x 51cm)
Collection of the artist

FRAME IT,
SHOW IT, SELL IT

Whether you choose to use your art as a personal hobby, a relaxing therapy or for purely aesthetic reasons, you will most likely come to a point at which you will want to display, show and/or sell your art. Use the same attention to quality for the presentation as you did for the creation of the paintings.

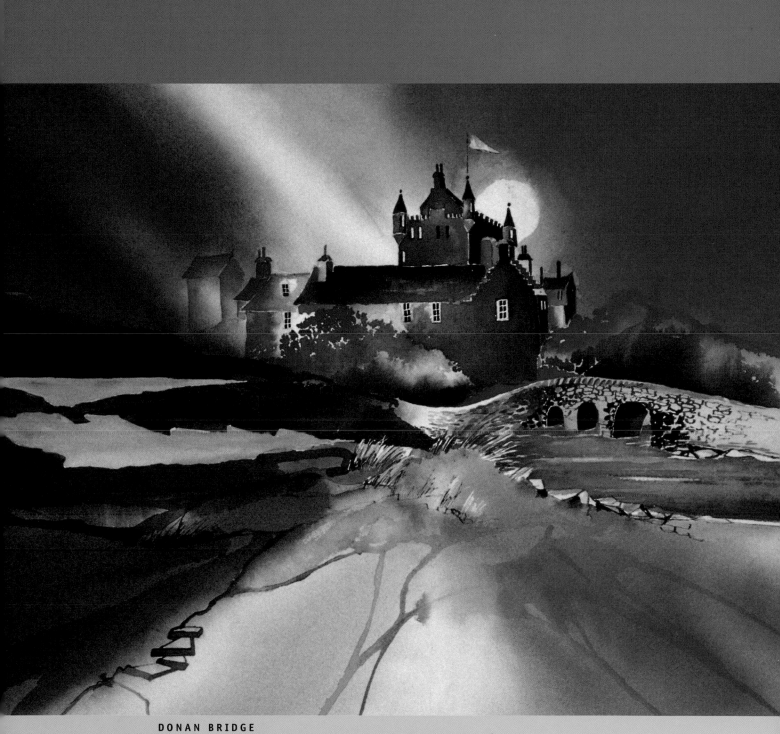

DONAN BRIDGE
14" x 21" (36cm x 53cm)
Collection of the artist

Frame Your Art

How you decide to display your art will impact the overall image of the painting. If you frame it well, your painting will be enhanced, but remember that framing should never dominate. It must support the theme of the work without distracting from it.

Matting

Measure for a Mat

The first step is to measure the amount of artwork you want to show. You can cover as little as ¼" (6mm) on the edges of your painting with the mat, but I usually cover at least 1" (3cm) so the painting does not bow out under the mat. This measurement becomes the inside dimension of your mat.

Determine Mat Border Size

Generally, if your artwork is small, the mat borders will also be small. If I frame a painting done on a full sheet of watercolor paper, I use an extra-large mat, perhaps 4½" (11cm) or 5" (13cm). The smallest mat recommended is a 2" (5cm) border. Traditionally, mat borders have equal top and sides, but they increase an extra ½" (1cm) on the bottom. This gives an implied visual weight to the bottom for a more balanced feel to the art in the frame.

Select Mat Color

The most common preference for color on a top mat is white or a light neutral shade. If you want to add some color to your matting, choose a color that will match the colors at your center of interest and use that color on a liner mat. That is a mat placed under the top mat. Usually, only ⅛" (3mm) to ¼" (6mm) of it shows as a thin liner around the inside dimension of your matting.

Consider Conservation

The primary consideration in choosing a mat should be its pH rating. The pH measurement is the rating of the chemical activity of acid in the board. A neutral pH is most desirable because using a mat board with even slight acidity may deteriorate your art. Various degrees of conservation are available:

- **Good**—Regular acid-free mat boards are good. They are made of treated wood pulp. The backing paper and core of these boards have been buffered with calcium carbonate to neutralize the acidity. The top facing papers have not been buffered.
- **Better**—Rag boards have backing paper and a core made of 100 percent rag and/or alpha pulp (wood pulp that has had the acid removed). The facing paper is made from alpha pulp. They are buffered with calcium carbonate for added protection. The colors are fade resistant.
- **Best**—A 100 percent rag board (also called a museum board) is a solid board made of cotton and linen rags that are made into pulp. These boards are completely acid free. The colors are fade resistant. A 100 percent rag board is the best protection you can put on your artwork. They are the only boards used by museums and fine art galleries.

2" (5cm)

Artwork 11½" × 16" (29cm × 40cm)

2" (5cm)

2" (5cm)

2½" (6cm)

Mat board

This cutaway shows that at least ½" (1cm) of the artwork should be covered by the mat on each side.

Foamcore backing board

The outside dimension of the mat is 16" × 20" (40cm × 50cm). The frame should be ordered as a 16" × 20" (40cm × 50cm) frame.

Add the vertical measurements:
2" + 11½" + 2½" = 16"
(5cm + 29cm + 6cm = 40cm)

Add the horizontal measurements:
2" + 16" + 2" = 20"
(5cm + 40cm + 5cm = 50cm)

MEASURING FOR A MAT
The image area (artwork) will be 11½" x 16" (29cm x 40cm). The outside dimension of the mat (which will be the frame size) is 16" x 20" (40cm x 50cm). The top and sides of the mat are 2" (5cm) wide and the bottom is 2½" (6cm) deep. It's best to add up all of the vertical measurements in one column and then add the horizontal measurements in a separate column.

Backing Material

Acid-free foamcore boards are a good backing support for works on paper. They come in ⅛" (3mm) to ³⁄₁₆" (5mm) sizes. These boards have a dense foam center between acid-free papers that have been buffered. Regular foam boards (not acid free) are available, but they will deteriorate your art over time.

Whatever backing material you choose, be sure to affix your artwork to it with two or three pieces of acid-free tape along the top edge.

Protect Your Artwork

The most commonly used material for protecting artwork on paper is glass. It is less expensive than other products, it is easy to clean and it doesn't scratch easily.

Acrylic, or Plexiglas, has the advantage of being virtually unbreakable, and it is lightweight. It does, however, scratch easily. When framing larger-sized pieces (over 15" × 20" [38cm × 51cm]), it is advisable to use acrylic to reduce the weight in the frame.

Glass is prone to condensation and so it should not touch artwork. Moisture can build up on the inside of the glass and deteriorate the art. A mat will separate the glass from the artwork.

Light rays can damage your artwork. Take care to protect watercolor paintings from ultraviolet (UV) rays. These rays are powerful enough to cause damage to organic materials, resulting in loss of color, yellowing and/or darkening. They can cause the paper to become brittle. UV-filtered glass or acrylic will block out most (but not all) harmful rays.

Color liner mat

White top mat

Framing and matting should enhance your painting, not dominate it.

Basic Framing

There are many options for framing. Should you choose a metal or wood frame? What width or profile would look best?

Begin with a few calculations to help determine the framing features that will best display your art:

1. **Face size.** The proportion of your artwork should be considered in choosing the profile size of the frame.

For example, a large painting will need a sturdy frame to hold the weight. A small piece of art with a delicately painted subject would look best in a thinner frame that reflects the feel of the work. Choosing a frame is part of the creative process. Look for the size and molding profile that best enhance your art.

2. **Depth of profile.** If you use two, three or more mats on your artwork, choose

a frame that has an inside depth (called the rabbet depth) that will accommodate those mats plus the glass, the artwork and the backing material.

3. **Style of frame.** If you have a painting of an old barn, a rustic wood frame may be appropriate. If you have a contemporary abstract, a metal frame may work best. The frame style should echo the style of the art, not distract from or dominate it.

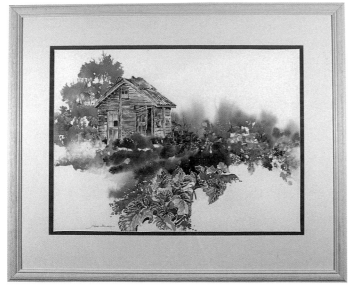

ART FRAMED WITH WOOD

ART FRAMED WITH METAL

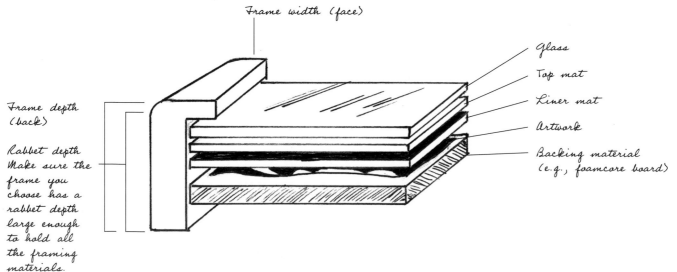

BASIC FRAMING FEATURES

Market Your Art

The purpose of marketing your art is to make prospective buyers aware of what you have to offer at what price and where and when the work is available for purchase. Start your marketing strategy by determining your intent, evaluating your artwork for its salability and setting a long-range marketing plan.

Determine Your Intent

- Do you want to simply enjoy the process of painting without displaying your art?
- Do you want to display your paintings only in your own home?
- Do you want to enter local, regional or national shows?
- Do you want to place your art for sale in art fairs?
- Do you want to sell your art in galleries?

Evaluate Your Artwork for Its Salability

- Do you like to paint subjects that strike an emotional chord?
- Does your art incorporate the current décor colors? It bothers artists that many buyers choose art based on their décor, but that is often the reality.
- Have you reached a level of competence that is competitive with other art at your marketing target? If you decide to show your work in a gallery, does your art compare with the quality of the other artists'? If not, try placing your paintings in shops or offices until you feel secure enough to approach a gallery. Entering art show competitions may help you decide

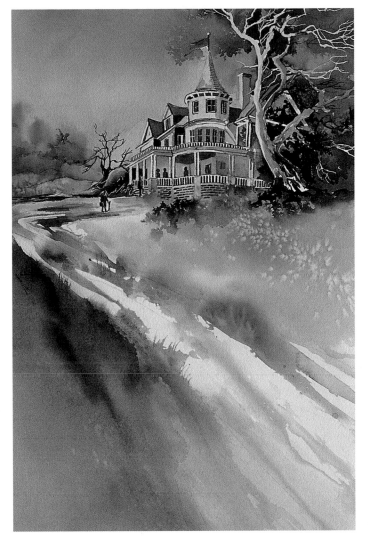

VICTORIAN HILLTOP
20½" x 14" (52cm x 36cm)
Private collection

where your competence level is. You may not agree with the judge, but you will be able to compare your art to everyone else's.

Set a Long-Range Marketing Plan

Once you determine what type of art you are most interested in creating and in which direction you will proceed to display, show or sell your art, you will want to develop a plan to help you achieve those goals. I began publicizing my work by entering local shows, offering to hang my paintings in businesses and change the art every six months, entering my watercolor paintings in poster contests, writing articles about my art for newspapers and magazines, donating my art to a benefit auction, and networking at area art organizations.

Tips for Selling Your Paintings

1. **Publicize your art.** Take advantage of every opportunity to get your name and your work out to the public. I have found that in order to get something you want, you have to give something. Be prepared to donate your time and perhaps some of your art in order to put your art in front of the public where it will be noticed. I offered to work at and donated art to an annual charity function. A few years later, that organization commissioned me to do a special painting as their "featured artist of the year" with signed, limited-edition prints of my painting. My payment was a number of the prints, which I could later sell, and a lot of free publicity.

2. **Join local art/watercolor organizations.** Enter their shows; write press releases for their newsletters; get involved in the group.

3. **Donate your art to local charities.** In return, ask them for a press release about your donation.

4. **Enter every art exhibition you can.**

5. **Offer to display your paintings at local banks, beauty shops, doctor's offices, restaurants**—anywhere that people wait for services. Be sure to ask permission to post your card with your name and the price of the art on it.

6. **Study current trends, colors and designs.** Stay in tune with what type of art buyers are looking for.

7. **Develop a resume and a portfolio of your very best work.** Carry this packet with you to show business owners with potential exhibit opportunities, gallery owners or even possible buyers.

PUBLICIZE YOUR ART

DEVELOP A RESUME AND PORTFOLIO

Price Your Art

If you decide to sell your paintings, consider the following questions:

1. **Who is going to buy your art?** Part of your marketing strategy should include a profile of your most likely buyers. List the age, income level, education and social status of your target buyer.

2. **Where will you display your art for optimal exposure to your target audience?** For example, wildlife art would probably sell better at sport shows and sport banquets than it would in a beauty salon.

3. **How will you price your art to increase sales?** It will be necessary to research the price tags on comparable art in your area. This is an important aspect of marketing. In pricing a painting, consider all of your costs: materials, overhead, transportation, insurance and, of course, a profit. Does the final tally compare to other art of similar style and artistic competence? Finally, you must consider what the market will bear.

No matter how you decide to display your art, your finished product should be original and show your own unique artistic expression and a maturity of painting competence. It must exhibit quality in its presentation.

CONCLUSION

The creation of art involves more than technical skill. It requires a reconstruction of what is seen and felt, along with the skill of manipulating the medium and communicating the message. It is a personal process of selecting, simplifying, exaggerating and making choices that reflect your own insights and personality.

We have studied the elements of good design. We have learned the principles of composition. By experimenting with techniques and how various products react with watercolor paints, we have found exciting ways to push the visual impact of the pigments. Through a series of demonstration paintings, we learned how to pour glowing glazes of pure, transparent colors. With that versatile background of techniques and applications, you can now be free to move beyond the normal safety of direct painting and established rules.

Art is an expression. Have fun expressing yourself in your own art. Hone your technical skills, but above all, enjoy the experience of painting. Watercolor is a unique medium; it has a living quality that begs for freedom.

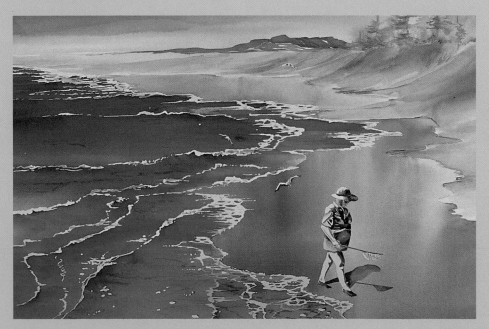

SHELL SEEKER
21" x 28" (53cm x 71cm)
Collection of the artist

index

This book gives you the confidence and skill you need to make the most of every second you spend painting. You'll learn a variety of time-saving techniques, create simple paintings in sixty minutes, then attack more complex images, breaking them down into a series of "bite-sized" one-hour sessions. Includes twelve step-by-step demos!

1-58180-035-5
PAPERBACK
128 PAGES

This extraordinary reference provides a wealth of gorgeous, crisp photos that you'll refer to for years to come. Finding the right image is easy—each bird is shown from a variety of perspectives, revealing their unique forms and characteristics, including wing, feather, claw and beak details. Four painting demos illustrate how to use these photos to create your own compositions.

0-89134-859-X
HARDCOVER
144 PAGES

CAPTURE THE MAGIC OF WATERCOLOR
with North Light Books!

Stop wasting hours searching through books and magazines for good floral reference photos. This wonderful reference puts more than 500 right at your fingertips! There are 49 flowers in all, arranged alphabetically, from amaryllis to zinnia. Each is showcased in multiple shots from different angles, including side views and close-ups of petals, leaves and other details.

0-89134-811-5
HARDCOVER
144 PAGES

Inside this incredible reference you'll find more than 1,000 definitions and descriptions—every art term, technique and material used by the practicing artist. Packed with hundreds of photos, paintings, mini-demos, black & white diagrams and drawings, it's the most comprehensive and visually explicit artist's reference available.

1-58180-023-1
PAPERBACK
512 PAGES

Claudia Nice introduces you to the joys of keeping a sketchbook journal, along with advice and encouragement for keeping your own. Exactly what goes in your journal is up to you. Sketch quickly or paint with care. Write about what you see. The choice is yours—and the memories you'll preserve will last a lifetime.

1-58180-044-4
HARDCOVER
128 PAGES